FIRST STEPS
S E R I E S

Drawing Cartoons

MARK HEATH

NORTH LIGHT BOOKS

Cincinnati, Ohio

About the Author

Mark Heath's earliest memories of drawing involve Mickey Mouse, laboriously traced from an encyclopedia listing. He sold them to other second-graders for fifty cents. Despite the lure of this easy life, he's gone on to draw his own material, which appears in magazines and greeting cards.

He is a contributing editor with *The Artist's Magazine*, and the publisher of *Encouraging Rejection*, a newsletter about cartooning. Every so often, he plays jazz trumpet in his living room until his upper lip blows out, a frayed reminder of why he draws for a living.

He lives in New Hampshire with Jayme, their cats Kiwi and Chance, and the occasional itinerant bear.

Drawing Cartoons. Copyright © 1998 by Mark Heath. Manufactured in the United States of America. All rights reserved. No part of this book may be reproduced in any form or by any electronic or mechanical means including information storage and retrieval systems without permission in writing from the publisher, except by a reviewer, who may quote brief passages in a review. Published by North Light Books, an imprint of F&W Publications, Inc., 1507 Dana Avenue, Cincinnati, Ohio 45207. (800) 289-0963. First edition.

Other fine North Light Books are available from your local bookstore or direct from the publisher.

02 01 00 99 98 5 4 3 2 1

Library of Congress Cataloging-in-Publication Data

Heath, Mark.
 Drawing cartoons / Mark Heath.
 p. cm.—(First steps series)
 Includes bibliographical references and index.
 ISBN 0-89134-826-3 (alk. paper)
 1. Cartooning—Technique. I. Title. II. Series: First steps series
 (Cincinnati, Ohio)
NC1320.H37 1998
741.5—dc21 97-36512
 CIP

Edited by Glenn L. Marcum
Production Edited by Michelle Kramer
Interior designed by Brian Roeth
Cover designed by Mark Larson

Dedication

Though we all travel our private roads, with luck we don't travel alone. This is for Jayme, forever at my side—occasionally at the wheel—and always in my heart.

Acknowledgments

I'd like to thank Greg Albert, who dispenses encouragement with the flair of a magician soothing a volunteer from the audience; Jayme Proctor, the magician's assistant, for insisting I could pull the rabbit from the hat, even when the hat seemed empty; Rick Stromoski, who inspires with his deeds and friendship; the National Cartoonist Society for lending a vital hand while I wrote this book; Sergio Aragonés and Dave Harbaugh and Paul Coker, Jr., who drew cartoons so perfectly I had to copy their styles; Mort Gerberg, who wrote a cartooning book that spoke to my heart; *The Artist's Magazine*, for allowing me to speak my heart to others; and finally, I'd like to thank all cartoonists, public and private, who strive to leave their mark on the world.

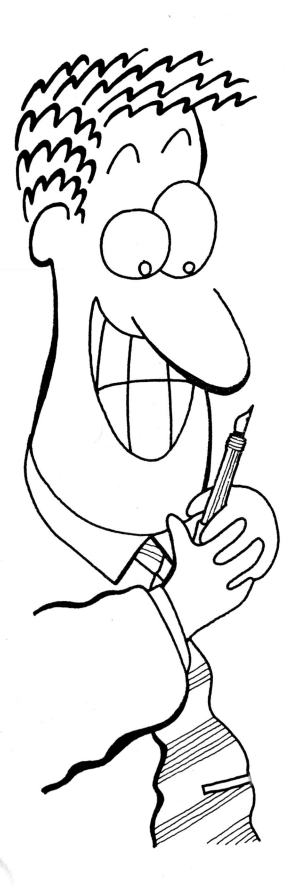
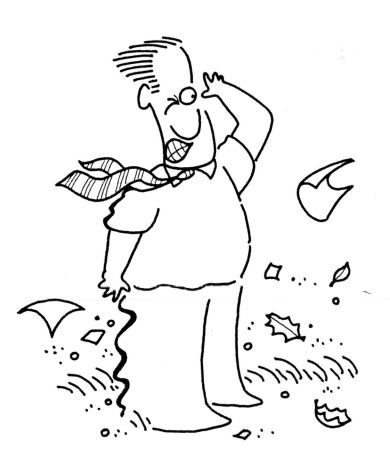
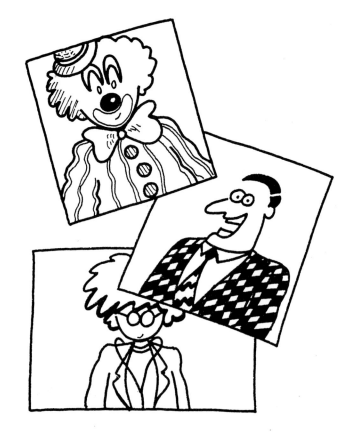

Table of Contents

Chapter One

A Head for Tools 9

Is the pen mightier than the brush? Here's a look at the tools that will get you started cartooning.

Chapter Two

Reading Faces 21

The eyes have it (as well as the mouth and ears and nose) in this exploration of the cartoon face.

Chapter Three

Getting Ahead With the Body 53

Give your cartoons a leg to stand on. This chapter demonstrates that the body has as much to say as the face.

Chapter Four

Odds and Ends 79

Now that your cartoon character is up and running, here are tips and suggestions for keeping it on track.

Road Directions

Some people are relaxed travelers. I'm not. Before a trip, I need to know mileage, motels, sites of interest—and that's for a drive to the post office. With my first cartoon, I had the same obsession: What should I draw with, and how should I draw it? *I wanted directions.* Cartooning was a desirable destination, but I didn't know how to get there.

And I didn't want to get lost.

If you share these concerns, I have good news. As long as you can lean back from a drawing and call it complete, you'll have your bearings. The cartoonist's destination is always a finished drawing.

As for getting there, that's the puzzle. If a fork in the road is perplexing, imagine the confusion of facing a dozen or more roads. There are many styles and techniques. Which do you choose?

Think of this book as a map and cartooning as a journey—not a topographical survey with precise directions, but the casual charting of a cartoonist. I'm offering suggestions. You're considering them. When you finish the last page, you'll have the information to set a course and write a map of your own.

And as the title promises, it's time for that first step (though, considering the distance ahead, I'd rather ride). You're at the wheel, I'm the backseat driver and our destination is the finished drawing.

Let's hit the road.

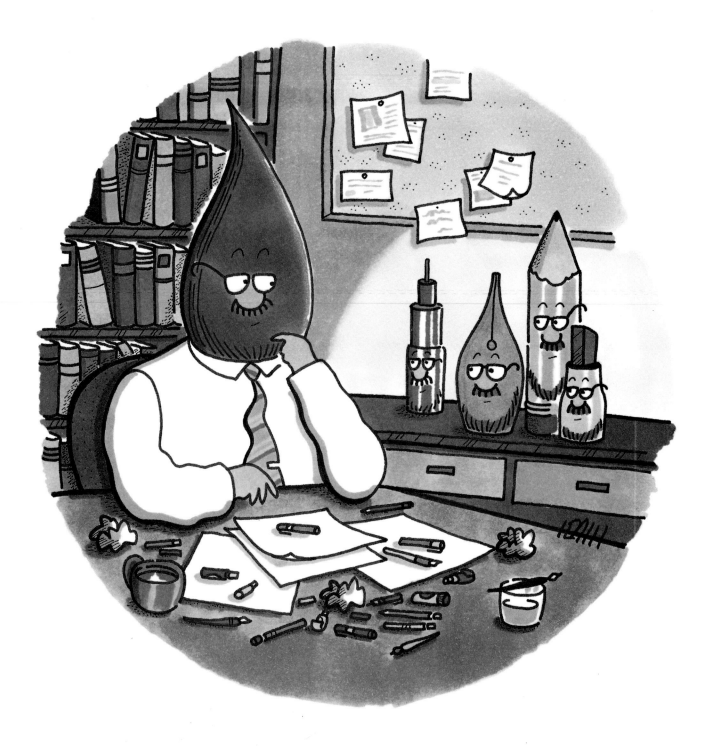

Chapter One

A Head for Tools

This is what I know about drawing with a brush: you can create lines both lush and precise; it demands more care than a marker; and I don't have a head for one. Though I admire the look of brushwork, it doesn't inspire me to practice it.

This could be laziness, but it's also something more. It's a thing of desire.

When you ask which tool is best, try them all. One will strike your heart like Cupid's arrow. It will seem ideal and irresistable, as if you've spotted the love of your life across a crowded room.

Of course, your skill won't be perfect at first—and to continue the introduction's travel metaphor, perfection is a road to avoid—but you'll desire the line with such passion that you'll gladly practice to know it better.

One other thing I know (though this would be a short book if that were literally true): A tool is only as good as the artist. Even a marker demands practice and experience: Will it bleed into the paper, smear the ink, withstand sunlight, blend smoothly or streak? Don't leave your tools idling on the table. Take the time to understand their quirks and preferences and you won't be disappointed.

The same could be said of any relationship, of course, but that's another book.

The Tool at Hand

I have a feeling that a cartoonist dropped in the deepest wilderness would manage to find a drawing tool: a twig and crushed berries, charcoal from a fire, the forgotten pen in a back pocket...

For the cartoonist, tools are everywhere and (nearly) any*thing*.

Let's say you take a phone message...

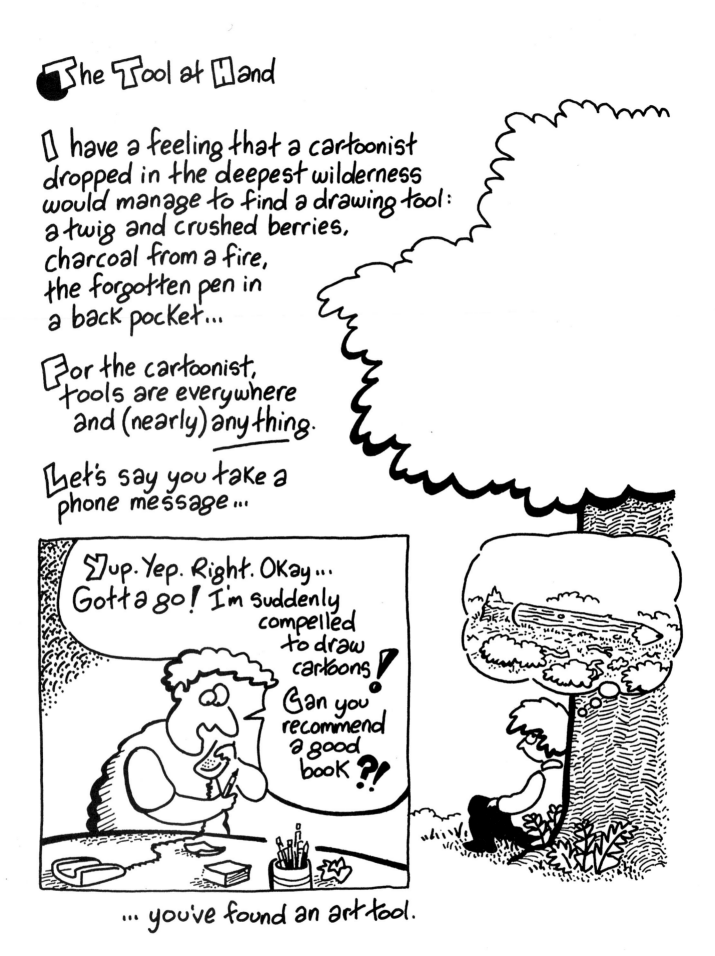

Yup. Yep. Right. Okay... Gotta go! I'm suddenly compelled to draw cartoons! Can you recommend a good book?!

... you've found an art tool.

Or you're canning beans, scribbling on the label with a marker...

or Jotting down a shopping list with an old pencil...

or applying your face paint...

bread
milk
drawing
paper

...You've found an art tool.

A ball point pen, a stubby crayon, a colored pencil, cat feet—

If it leaves a mark, you can draw with it.

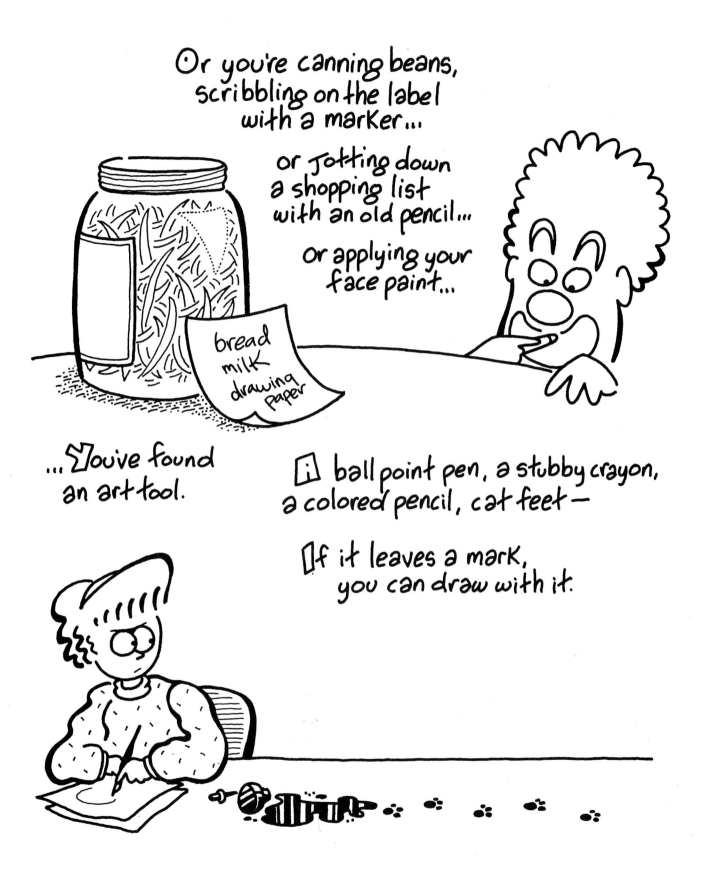

Once you've plundered your home for tools, try an art store.

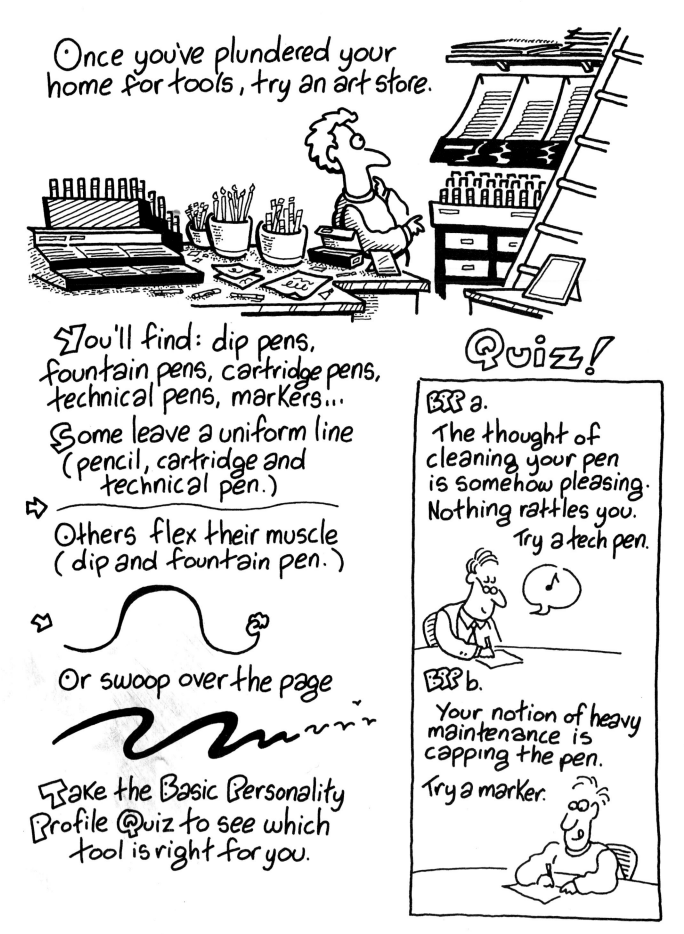

You'll find: dip pens, fountain pens, cartridge pens, technical pens, markers...

Some leave a uniform line (pencil, cartridge and technical pen.)

Others flex their muscle (dip and fountain pen.)

Or swoop over the page

Take the Basic Personality Profile Quiz to see which tool is right for you.

Quiz!

a.
The thought of cleaning your pen is somehow pleasing. Nothing rattles you.
Try a tech pen.

b.
Your notion of heavy maintenance is capping the pen.
Try a marker.

BPS c.

You're a bit of <u>a</u>, a bit of <u>b</u>... You don't mind cleaning, and you like a spontaneous line. Try a brush. Wear old clothes.

BPS d.

You're <u>a</u>, <u>b</u> and <u>c</u> (you hate to clean, you like control, and you want to seem looser than you really are.) So you cheat with a cartridge pen. I'm a <u>d</u>. I pretend to use a flexible nib by fattening the uniform line.

BPS e.

None of the above. You hate quizzes, you're absolutely unique, and you will <u>never</u> be typecast! (but since life is ironic, you're still a Type <u>e</u>.)

A few words on Color

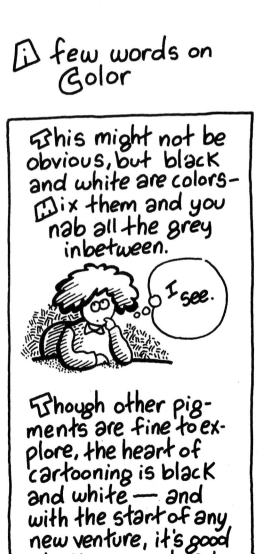

This might not be obvious, but black and white are colors— Mix them and you nab all the grey inbetween.

I see.

Though other pigments are fine to explore, the heart of cartooning is black and white — and with the start of any new venture, it's good to know your heart.

Paper

Like the drawing tool, anything goes. I've drawn on paper towel because I liked the fuzzy line.

You can use: construction paper. tracing paper, watercolor paper...

The paper I use the most is Bond. It's smooth, inexpensive, and available in the perfect size of $8\frac{1}{2} \times 11$.

I buy it by the case — 10 reams (500 sheets to a ream.) It's an imposing stack, but you'll reach that last piece in no time.

You can order the paper from a local printer, or an office supply catalog.

Note:
Check that the paper accepts your pen... inks vary, and the brand you use might bleed in the paper or leave too-grey a line...

Different jobs suggest different papers.

I used 4 for this book:

1. Bond for roughs and layout.

2. Tracing paper for finished art, until I switched to...

3. Marker paper. It's sturdier, with a smooth finish. I also used it for my lettering.

4. Bristol vellum. I used this for tonal illustration: it absorbs the marker's ink and hides the nib strokes.

Remember: The paper you choose is just as important as the brush, pen, or pencil.

Rubbing Out Erasers

If you draw with a pencil, you'll be tempted to erase — which is fine in moderation. But if you worry over each line like a dog with a bone, you'll gnaw your drawing into an uninspired mess.

Cartooning isn't about perfection...

Not bad...

Could be better...

...it's about expression.

That's why I like to use ink. Though a line can be changed (with a paper patch or white paint), it's more bother than erasing...

...I'm encouraged to give each line a chance before starting over, to remember that an apparent flaw is likely an expression of my style.

This line is way off... Great!

Some artists draw on limber tables that bend up and down, and sit on chairs that suit any posture.

But a great cartoon doesn't demand great finance. More often than not, my drawing table is a lap desk, and my chair is the living room couch (which also adjusts to my posture.)

A swivel lamp can swing to either side of your hand, eliminating the shadow...

...but a properly placed lamp can do the same trick.

Theme Music

A cartoon is visual jazz — the drawing isn't a straight-on rendition, it's a variation on a theme.

But to improvise, you need to <u>know</u> the theme...

I think it's time to re-search Bugs Bunny.

Here are some reference sources to keep in mind and on hand:

Pictorial dictionaries

Vcr (TV props/settings)

Internet (search engines will find images)

Gift catalogs

Stock photo catalogs

Children's reference books are great for showing the basics.

The Impossible Dream Tool

Cartoonists may dream of the perfect tool — the one that makes drawing automatic and effortless — but only practice and time will work that magic.

If you decide to buy an expensive fountain pen, that's fine. If you choose to go with a disposable ball-point, that's fine, too.

But the only indispensable tool is you.

Did you hear that, you arrogant pen? You're nothing without me! I'm indispensable!

Not to mention the sort of person who talks to pens...

Reading Faces

Y ou've noticed that I refer to the *reader* of cartoons, not the viewer. Though this is a topic for another book (I recommend several in the bibliography), a cartoon often comes with a caption. And even when it doesn't, the cartoon is still read.

It's a genetic compulsion. As babies, we're designed to recognize adult faces, to read their expressions. Long after the crib, we continue to spot faces in clouds and trees and even the moon. Given the slightest of lines, we'll always see someone looking back at us. And we'll forever examine what we see for meaning.

If you've been online, you've discovered emoticons, punctuated faces that comment on typed words. Though the faces are abstract and sidelong, their expressions are clear. For example, this triad of keyboard symbols :-o is unmistakably a surprised face (as in: *I've been nominated? I didn't even* know *there was a Nobel Prize for cartooning :-o*). And if I choose to announce that I've won this award, a typographical wink at the end ;-) would reveal that the honor is premature.

The need to read body language is intense and inevitable. If I insist that *Cartooning's OK, but I'd rather bag groceries ;-)* the simple face at the end speaks the truth and gets the last word.

And as you'll discover, the simple face gets the first word in cartooning, as well.

Getting In Shape

We've all seen people with heads shaped like blocks, peanuts, balls, and so on. A cartoon head shares the same form...

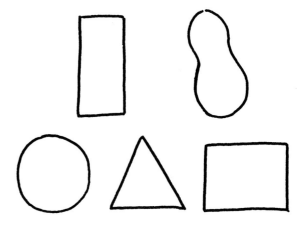

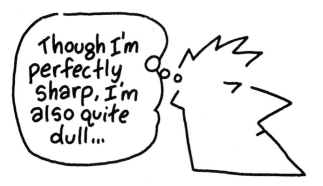

Though I'm perfectly sharp, I'm also quite dull...

... but since people rarely offer perfectly sharp corners, round off the tips...

... and unless the character is bald, you'll need to add hair...

... affixing the ears will reveal how much hair to add, and where to place it.

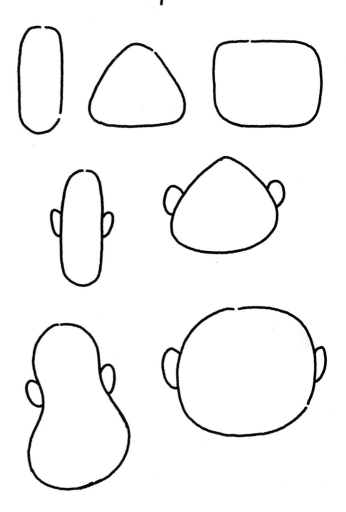

Though a real head may sport 100,000 strands of hair, you only need to draw a few... as you'll soon learn, cartoons suggest detail, rather than show it.

Think of hair as a hat, a shape that sits on the head, just over the ears.

And like a hat, you may need to stretch it to fit every head.

Sometimes, there's little difference between a man and woman's hair.

In fact, because fashion is frequently short-lived, I generally ignore it and devise my own hair-styles.

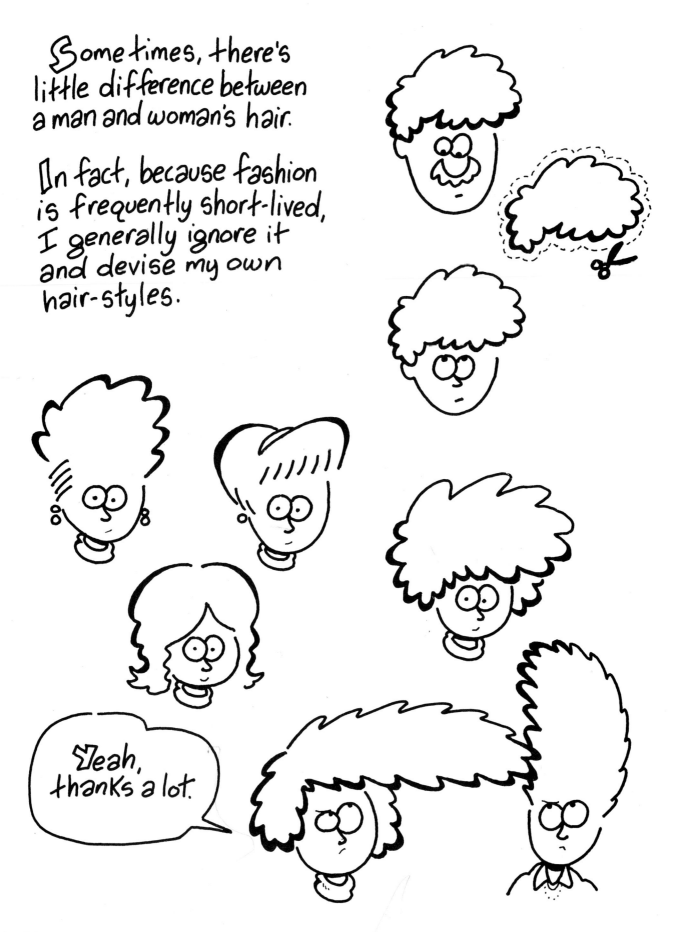

Yeah, thanks a lot.

Hair Top and Bottom

Beards are often hairstyles turned upside down.

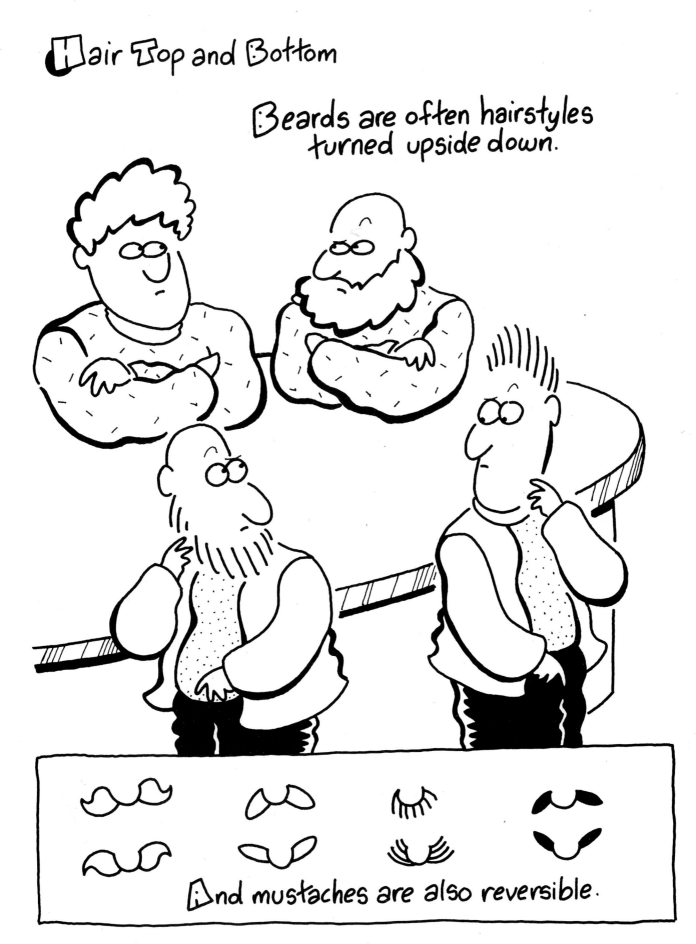

And mustaches are also reversible.

With so many parts to the face and head, where do you begin?

You need a feature to anchor the art.

I like to use the nose.

5 steps to dropping anchor:

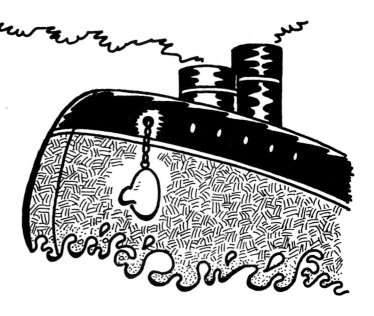

1. Anchor's aweigh
2. The ear sits opposite the nose.
3. The chin (or is it the neck?)
4. Ever notice that step-by-step instructions point out the obvious?
5. Done.

If starting with another feature is more comfortable, feel free to cut the nose to start the face.

ace Value

When you study a face, you primarily notice the eyes and mouth — they reveal the emotional difference between...

Have a nice day. And Have a nice day.

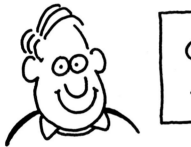

Extreme emotions are easy to draw. A big smile, a deep frown, a grimace, and you've captured joy, sadness, and anger.

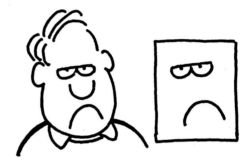

But to portray the emotions in-between, you need to look the face in the eye...

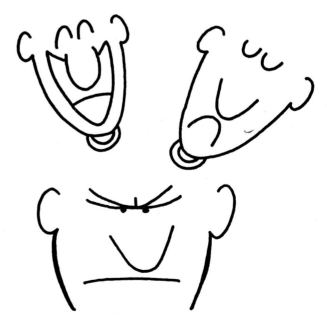

27

...lots of eyes.

Try this:

Fill a page with ovals, and give each a different set of eyes...

(ever have the feeling you're being watched? It's amazing that a cartoon eye can suggest the real-life sensation of eye contact.)

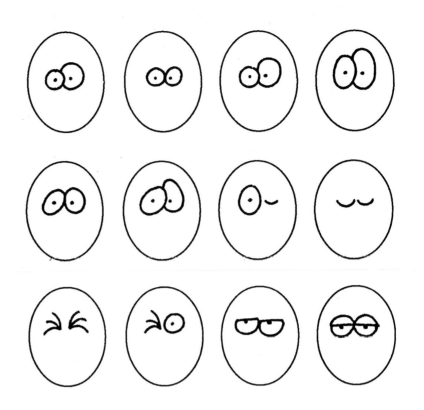

... on a sheet of tracing paper (or thin bond), supply a set of mouths ...

(and maybe I'm especially sensitive, but I'll feel sad if I stare at a cartoon frown long enough... another reminder that a "simple" drawing is often rich and complex.)

Now overlay the two sheets. I've been cartooning for years, but this trick still surprises me. Suddenly I'm confronted by dozens of distinct personalities.

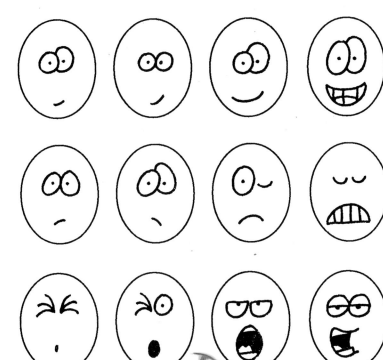

Body language is subtle — until you see how the mouth and eyes interact, it's hard to predict which emotion will appear.

(even without speaking, a face is always talking...)

To learn this language, you must draw it. Keep the results on hand for study and practice.

Soon you'll be drawing "rueful consternation" and "glib anxiety" with "reckless abandon."

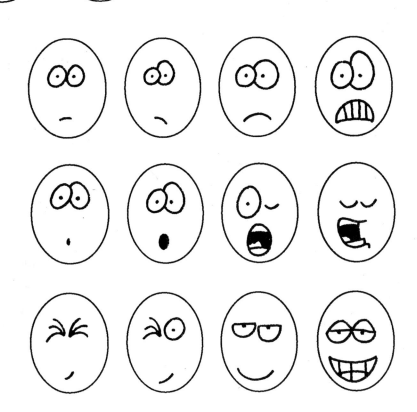

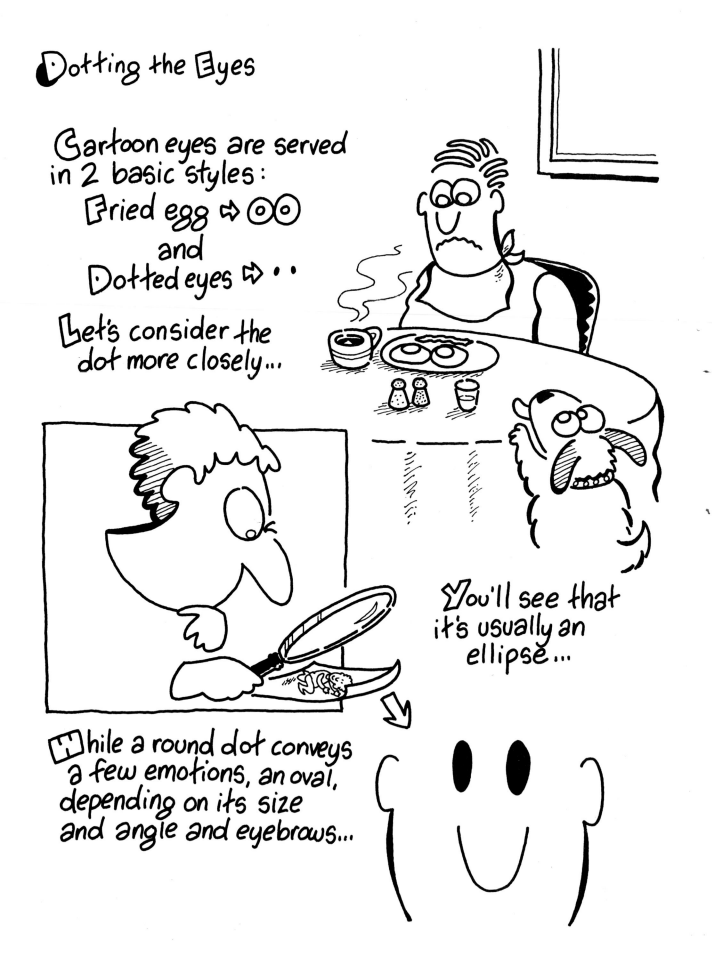

Dotting the Eyes

Cartoon eyes are served in 2 basic styles:
Fried egg ⇨ ⊙⊙
and
Dotted eyes ⇨ • •

Let's consider the dot more closely...

You'll see that it's usually an ellipse...

While a round dot conveys a few emotions, an oval, depending on its size and angle and eyebrows...

... can display <u>all</u> emotions.

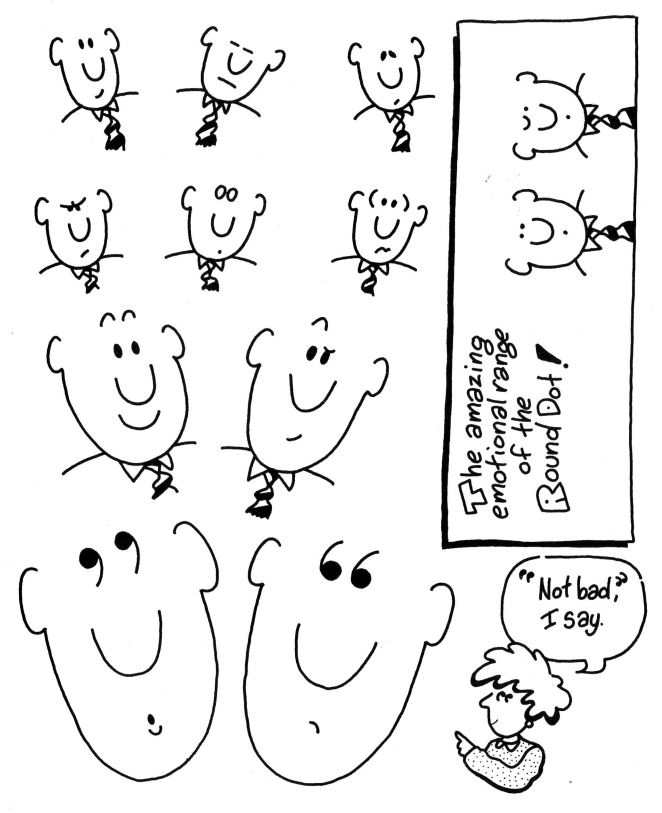

Now crack an egg open and try these.

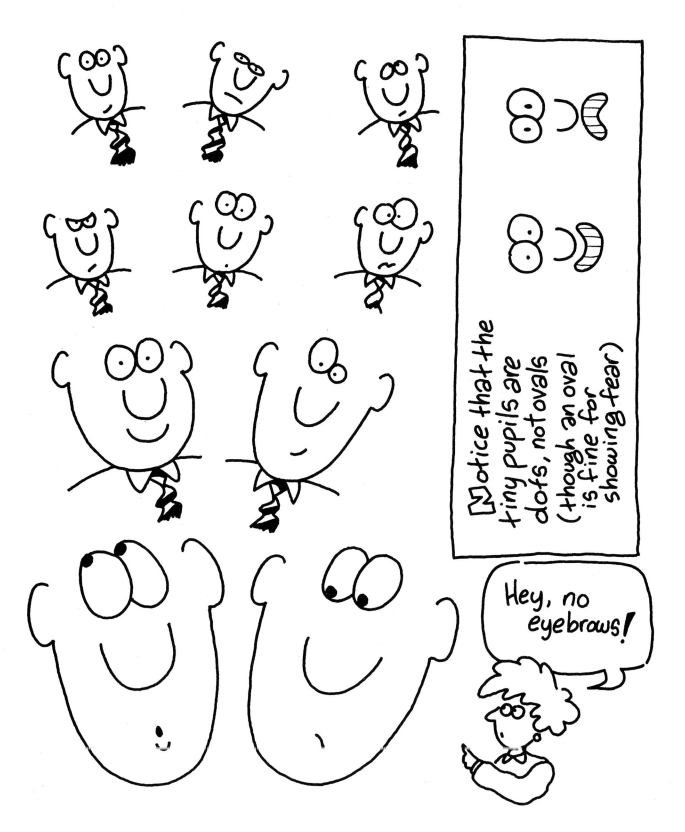

Notice that the tiny pupils are dots, not ovals (though an oval is fine for showing fear)

Hey, no eyebrows!

32

Eyebrows are great for showing emotion

even when you don't use them.

The pupil in the cartoon eye is the comic focus.

For example, if this character delivers a punch line...

... would it be funnier if he looked up, down, sideways, or at you?

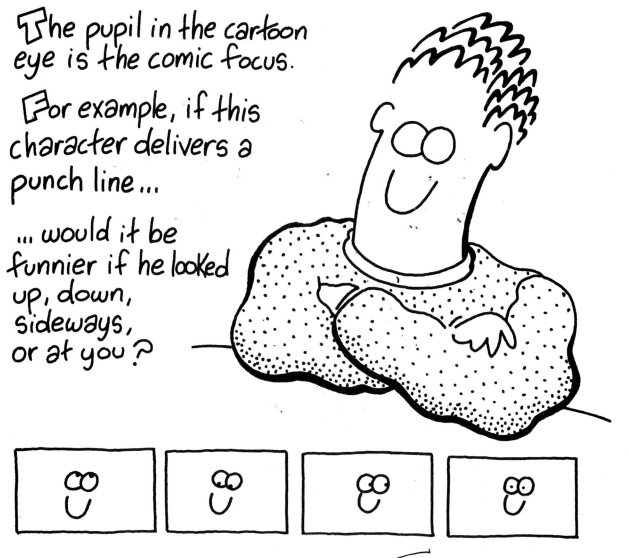

It depends on the joke,
and the cartoonist.
I often can't tell until
the drawing's finished,
which is why I leave
the pupils for last.

You can use
tracing paper
to ponder your
options.

And if you still
can't see a solution,
you might want
to try...

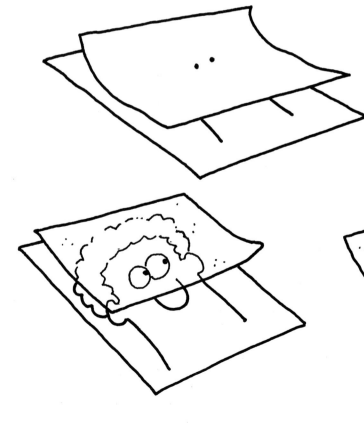

Glasses

When a character wears glasses, it's not to see better...

... they're meant to help the reader see the character better...

Glasses convey mystery intelligence, stupidity, elan...

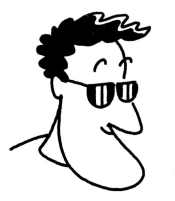

And when you absolutely can't find the right eye, a pair of inscrutable glasses hides the problem.

But don't do this too often.

You'll create livelier cartoons if you show the eye as often as possible...

... but not <u>too</u> much of the eye.

While a real orb might look like this...

... it's an eye-sore in a cartoon face.

The same restraint applies to the other features.

If you like the extra detail, you might have a talent for caricature. Check out my Recommended Reading list for book suggestions.

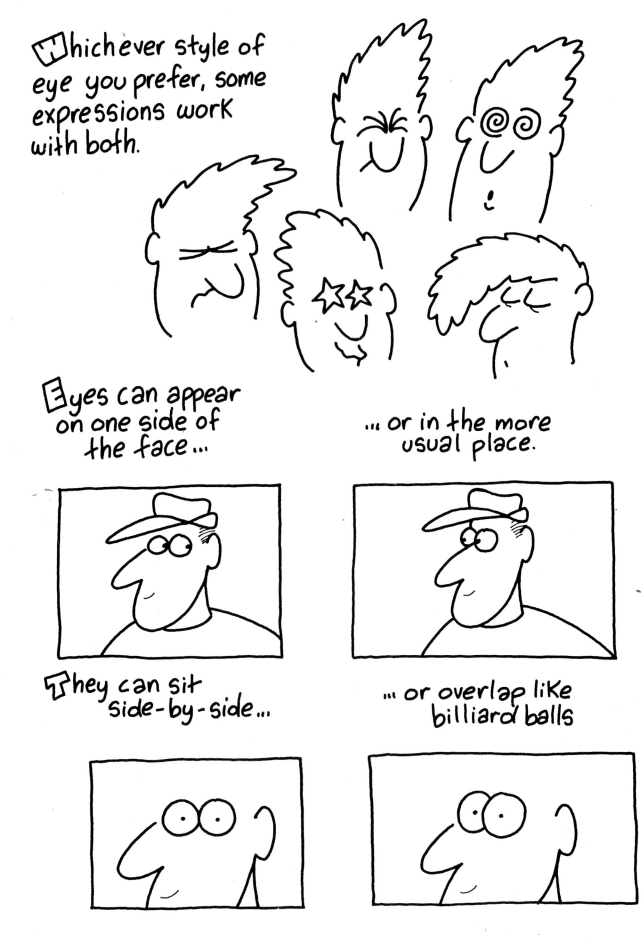

Whichever style of eye you prefer, some expressions work with both.

Eyes can appear on one side of the face...

...or in the more usual place.

They can sit side-by-side...

...or overlap like billiard balls

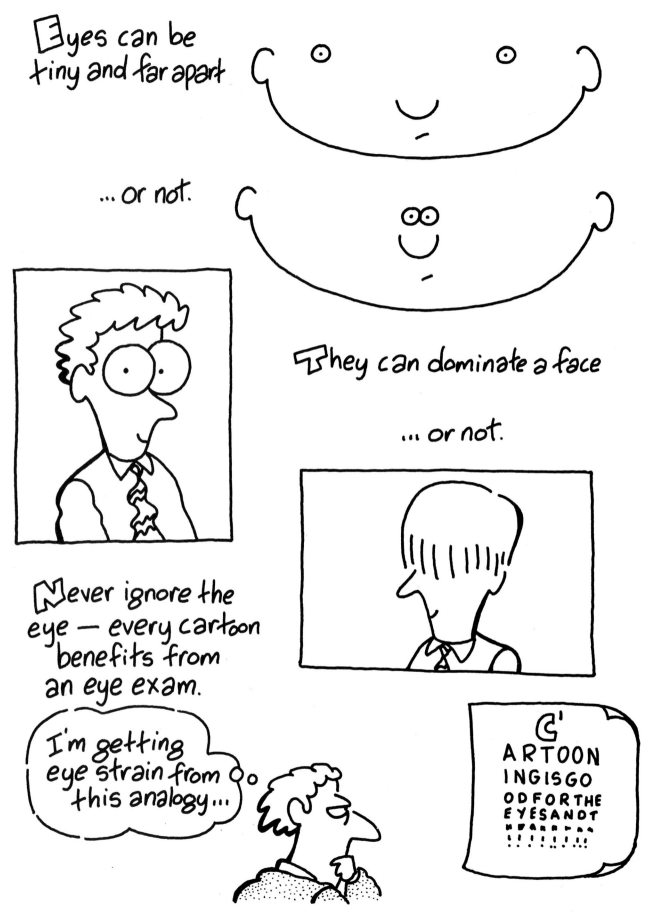

Speaking of the Mouth

Along with the eyes, the mouth tells the reader what the character is

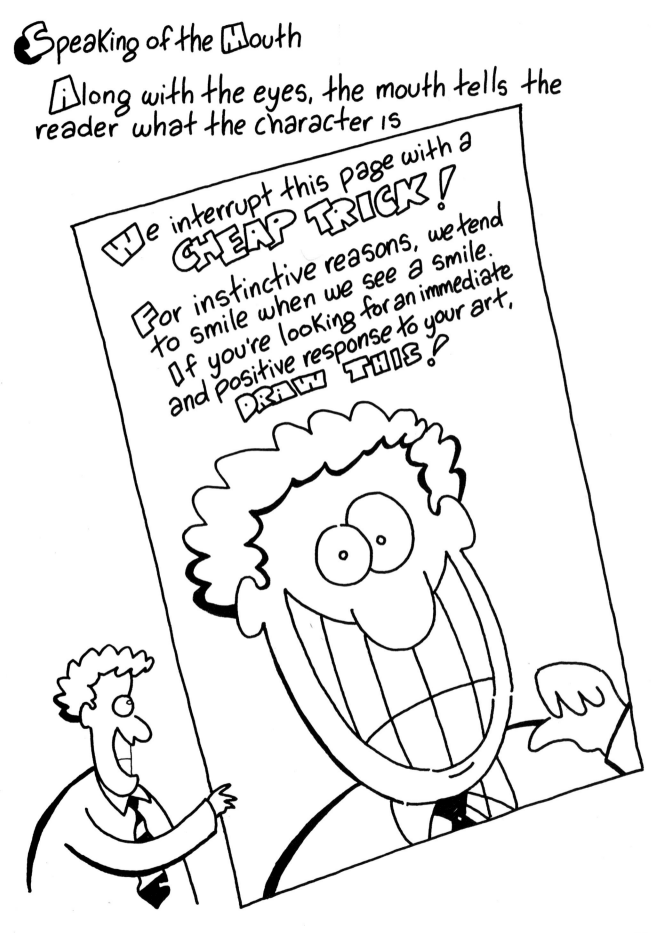

We interrupt this page with a CHEAP TRICK!

For instinctive reasons, we tend to smile when we see a smile. If you're looking for an immediate and positive response to your art, DRAW THIS!

Speaking of the Mouth

Along with the eyes, the mouth tells the reader what the character is thinking/feeling. And as with all things cartoonish, you have many ways to show this...

Like the eyes, the mouth can migrate to one side of the face...

Read These Lips*

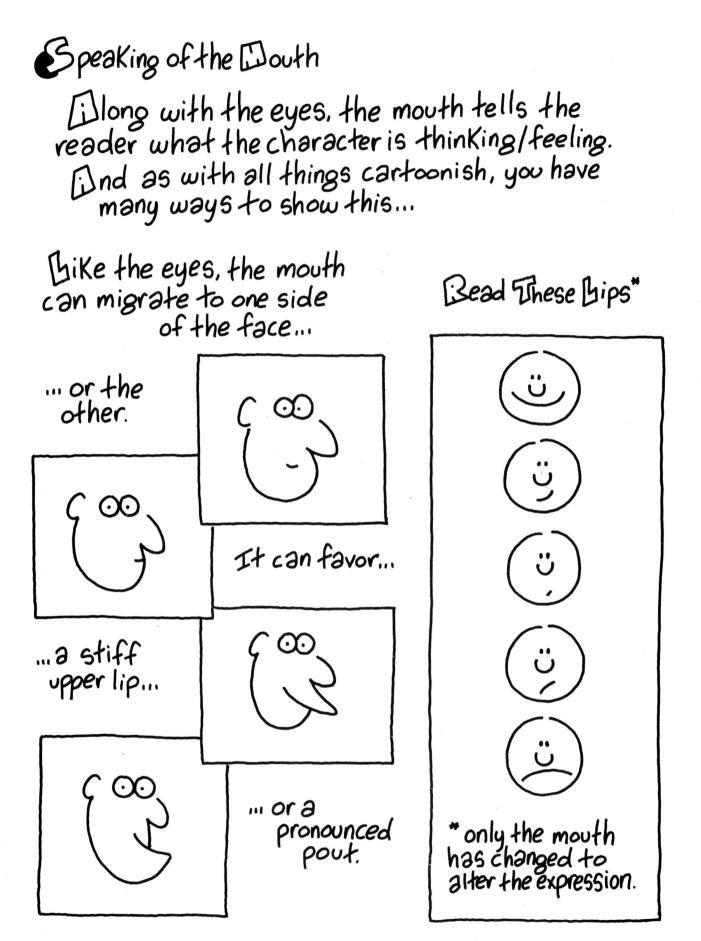

... or the other.

It can favor...

...a stiff upper lip...

... or a pronounced pout.

* only the mouth has changed to alter the expression.

On occasion, the mouth ventures beyond the pantomime of body language and speaks a few words. It's good to remember that when someone gives their two cents worth, that's a modest exchange...

... not something to shout about.

If you crank the mouth wide for normal conversation...

... you'll really need to stretch to show a character yelling.

Of course, if that appeals to you, stretch away. There are many styles — perhaps yours will shout for attention.

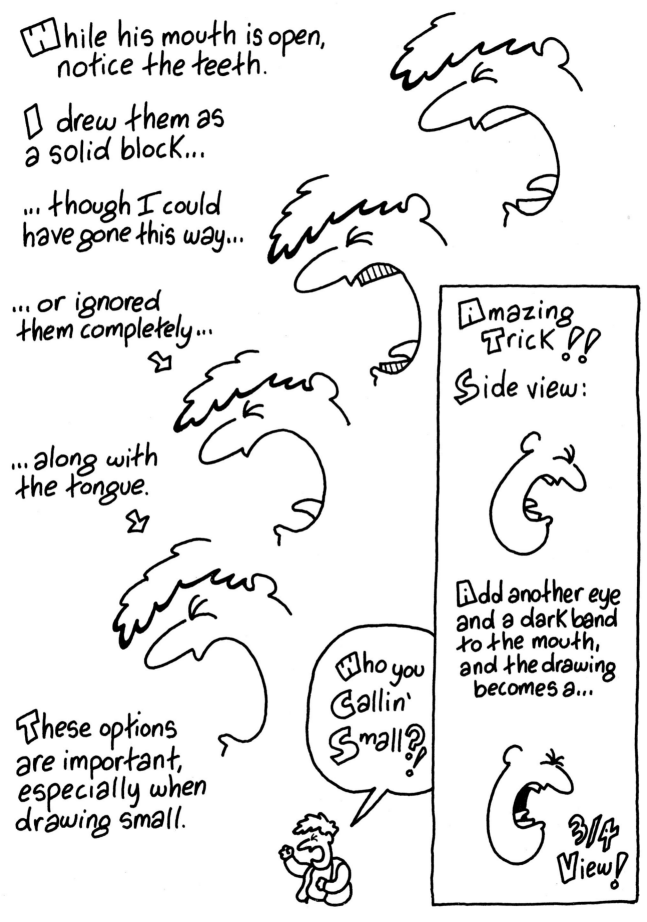

While his mouth is open, notice the teeth.

I drew them as a solid block...

... though I could have gone this way...

... or ignored them completely...

... along with the tongue.

These options are important, especially when drawing small.

Who you callin' small?!

Amazing Trick?!

Side view:

Add another eye and a dark band to the mouth, and the drawing becomes a...

3/4 View!

On the other hand, if you're drawing large and up-close, extra detail is fine.

(This may startle the timid reader, so use the effect sparingly.)

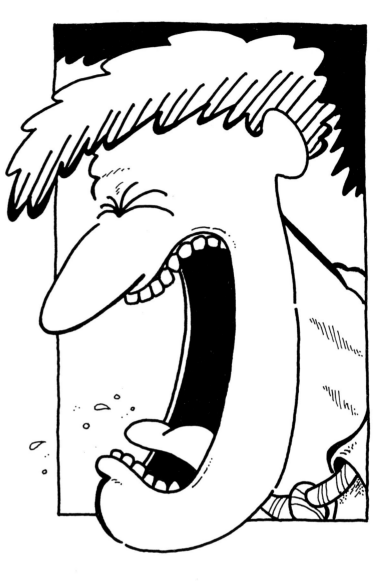

⇧

By the way, notice anything odd about this guy?

Right. No mouth.

Egad!

The mouth has other chores...

1. Eats lemon.
2. To his amazement, discovers that it's sour.
3. Feels ill
4. Short-term memory loss. Desires another lemon.

1.

2.

3.

4.

Notice that the eyes never changed. (not too bright a guy.)

But imagine how the cartoon might have improved had the eyes shown some emotion.

I prefer less emotion.

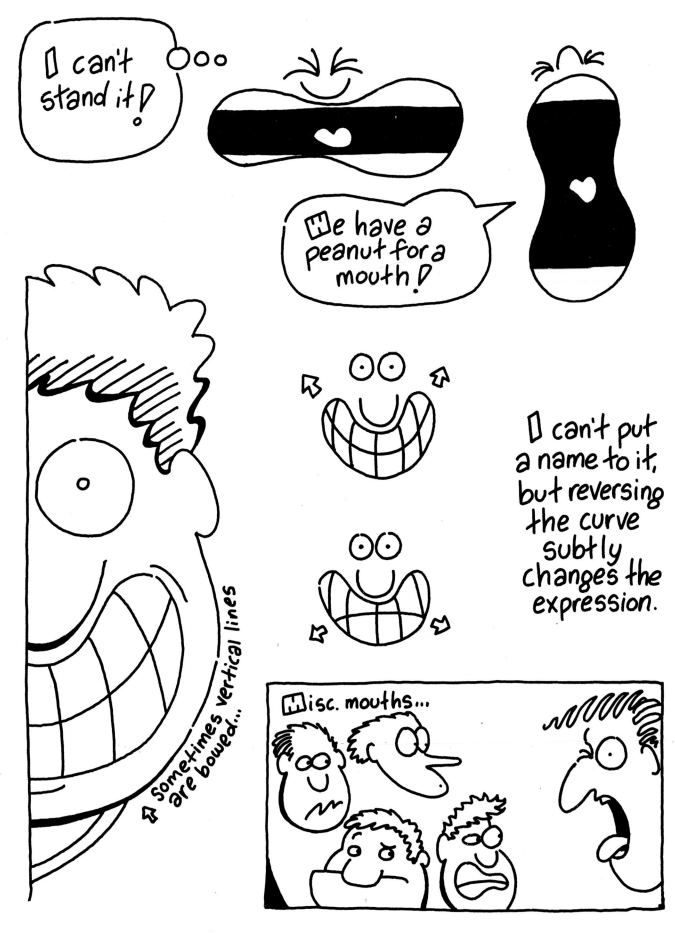

Nose

Pick a shape. Any shape...

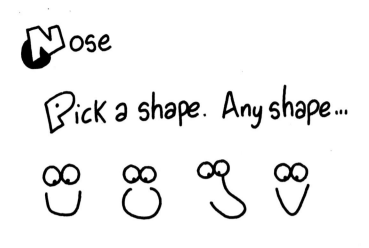

... and any size ...

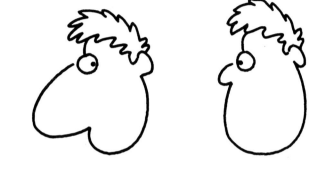

There's not much to say about the nose. Unlike the eyes and mouth, it can't reveal thought or emotion...

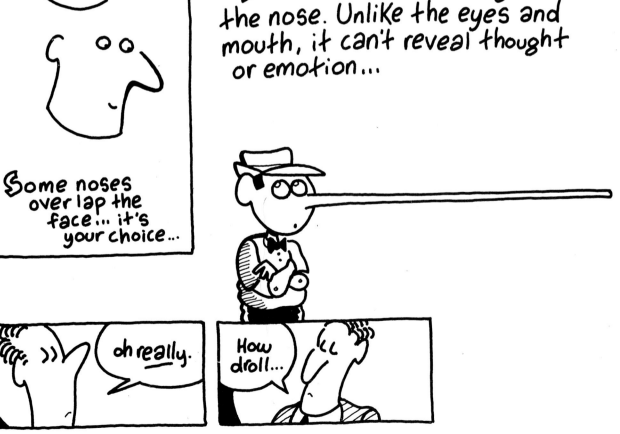

Some noses overlap the face... it's your choice...

oh really.

How droll...

And Ears

What I said about the nose goes double for the ear.

They hold glasses and earrings; they wear headphones and muffs – but they have little to say.

Ears are even shaped like noses... Usually.

Some cartoonists ignore the nose...

...or the ears...

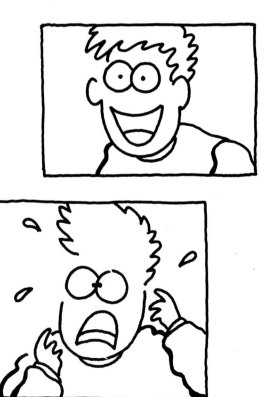

...but rarely both.

The Angle on Angles

In life, you'll occasionally see a face head-on, but usually it's at an angle (even face-to-face, few can maintain constant eye contact.)

No one expects a cartoon to be realistic, but a good cartoon should _seem_ real.

The reader instinctively looks for visual cues, such as perspective and stance (which I'll discuss in the next section) and _angle_.

Cartoon characters in constant profile seem stiff and unnatural...

... while those at an angle are more believable.

He's as real as I am!

(unless you want a rigid character; a soldier at attention, or a patient enduring a physical exam...)

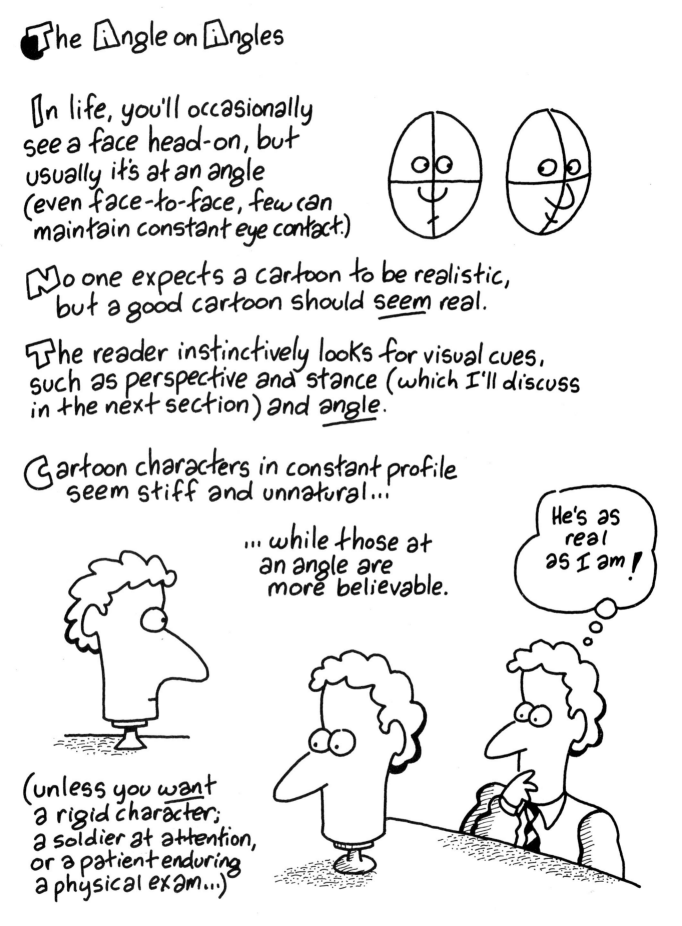

You'll have a tendency to favor a left or right-facing character.

Practice both.

And while you're at it, don't hesitate to get behind your drawing.

The more angles you master, the more comfortable you'll feel drawing.

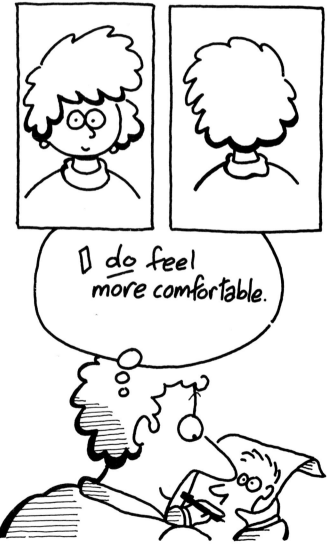

Out of Shape.

Short of drafting tools, it's impossible to draw perfect shapes —
and unnecessary.
A cartoon should suggest an image...

... not perfect it.

Circles

Draw with your arm, not just your hand. And once you begin, don't stop.

If you do — perhaps the paper's tooth drags the pen nib — leave a break between lines.

The reader's eye will bridge the gaps.

Boxes

Draw the parallel lines in sets — top and bottom, side and side.

If the box is out of square, few readers will notice.

Lines

Draw fast — the faster the stroke, the straighter the line... if you slow down, the line may wobble.

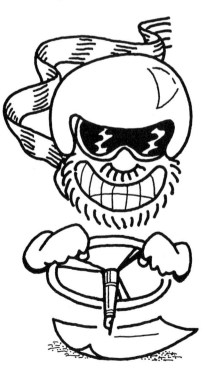

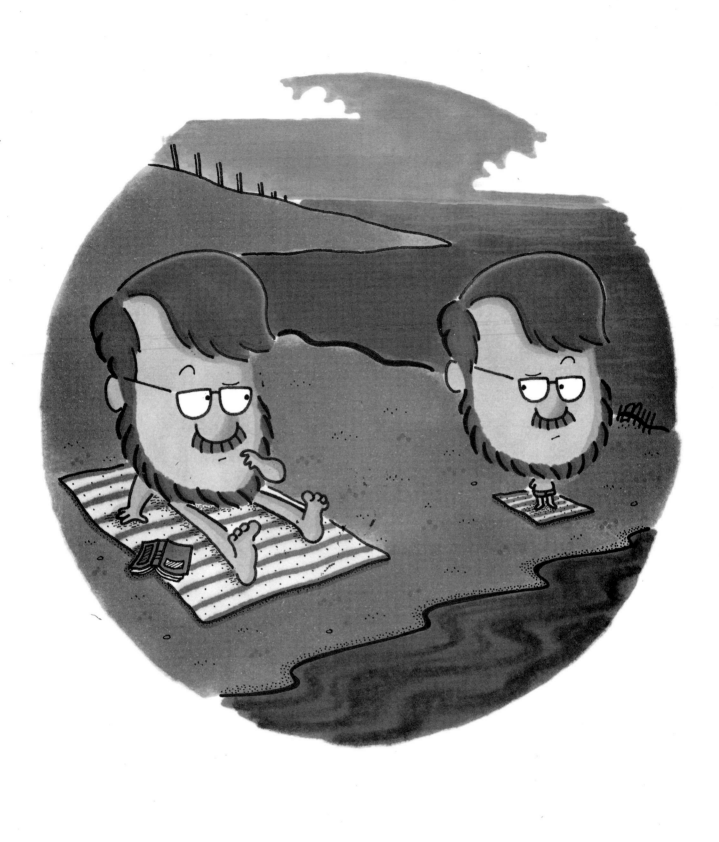

Chapter Three

Getting Ahead With the Body

When I first began cartooning, I loved drawing neckties. They dangled from the head like kite tails, seeming to steady and complete the art. I flew high with such fashion for many years before I noticed that the head was all dressed up with no way to go.

It lacked a body.

Drawing more than the head is a challenge. For a good while, I compromised by drawing a miniscule form that denied scrutiny. If the arms or legs didn't sit well on the body, who could tell? And later I ignored the torso entirely with limbs sprouting from the head like shoots from a potato.

These two solutions are fine if they allow you to say all you desire as a cartoonist. But after a while, I found it difficult to supply props for the tiny body guy—it seemed unlikely that a phone manufactured for a giant head, for example, could be supported by such puny arms—and the bodiless character was hard to dress. As my ambition grew, I discovered that clothing and props lend much to a cartoon. And to display them clearly, you need a body.

You need a body, in fact, to do and say many things. So while you can focus on your career as a cartoonist of neckties, give the body a chance. Once your cartoon has legs, you'll be surprised by how far it can go.

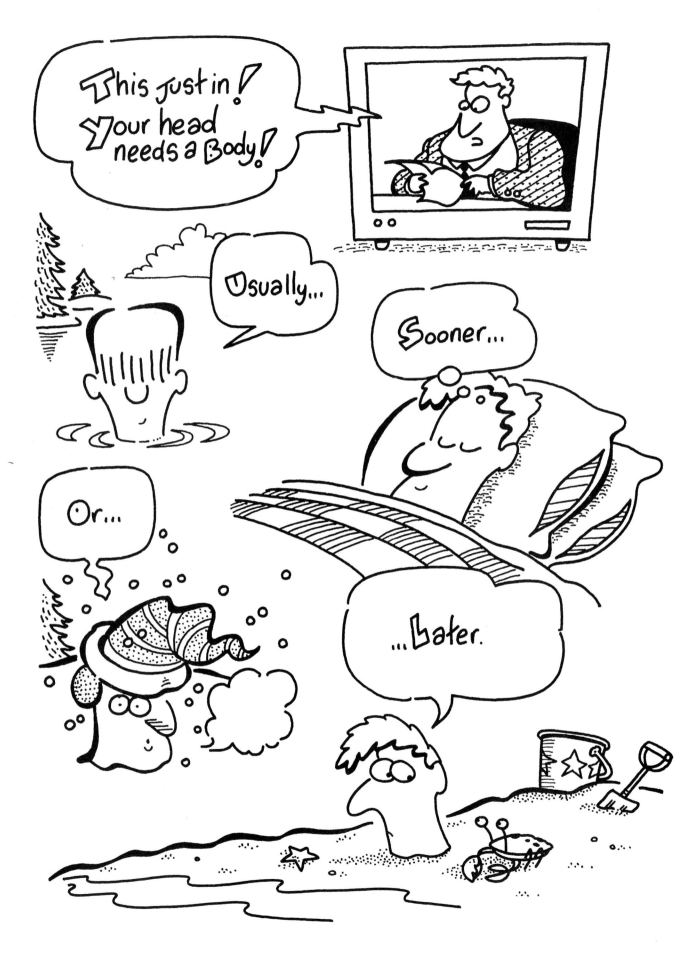

And for the beginning cartoonist, that's the biggest challenge...

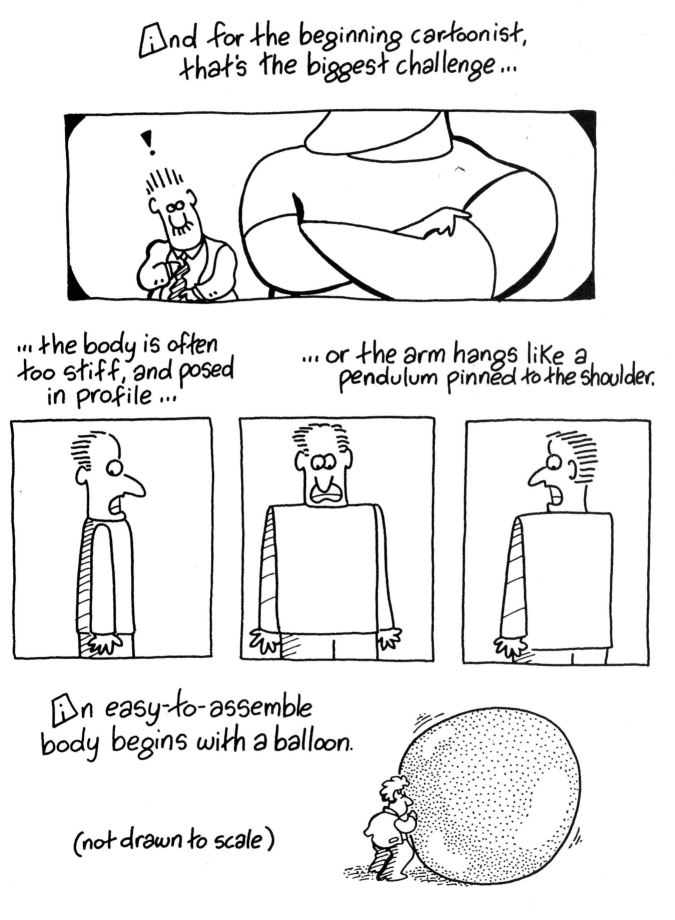

... the body is often too stiff, and posed in profile ...

... or the arm hangs like a pendulum pinned to the shoulder.

An easy-to-assemble body begins with a balloon.

(not drawn to scale)

Pretend it's
a torso.

I see it!

Or a fly on
a grape...

I see it!

Add a pair of
curved lines.

Gap them — now
you have sleeves.

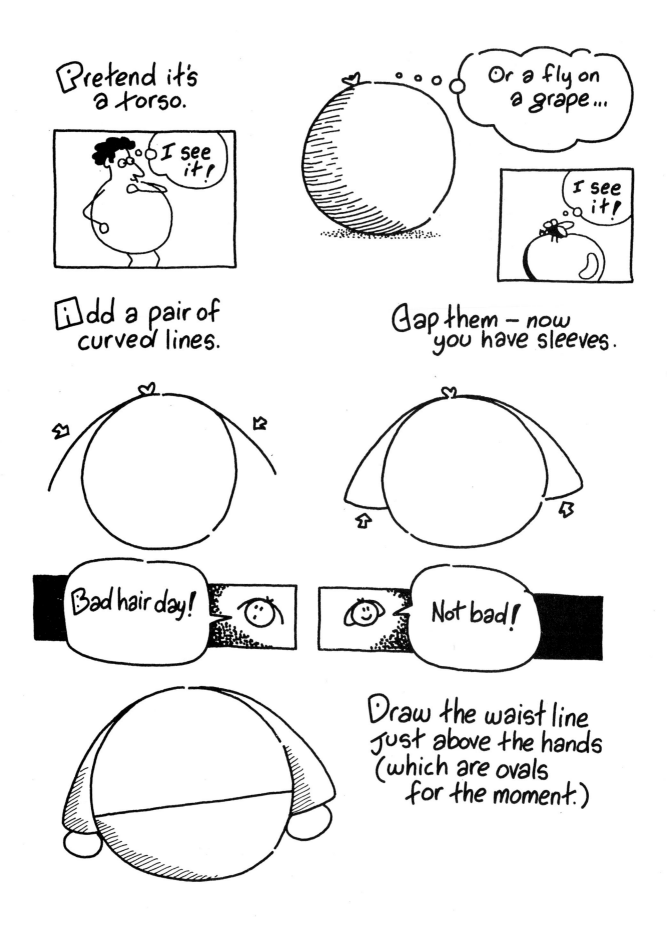

Bad hair day!

Not bad!

Draw the waist line
just above the hands
(which are ovals
 for the moment.)

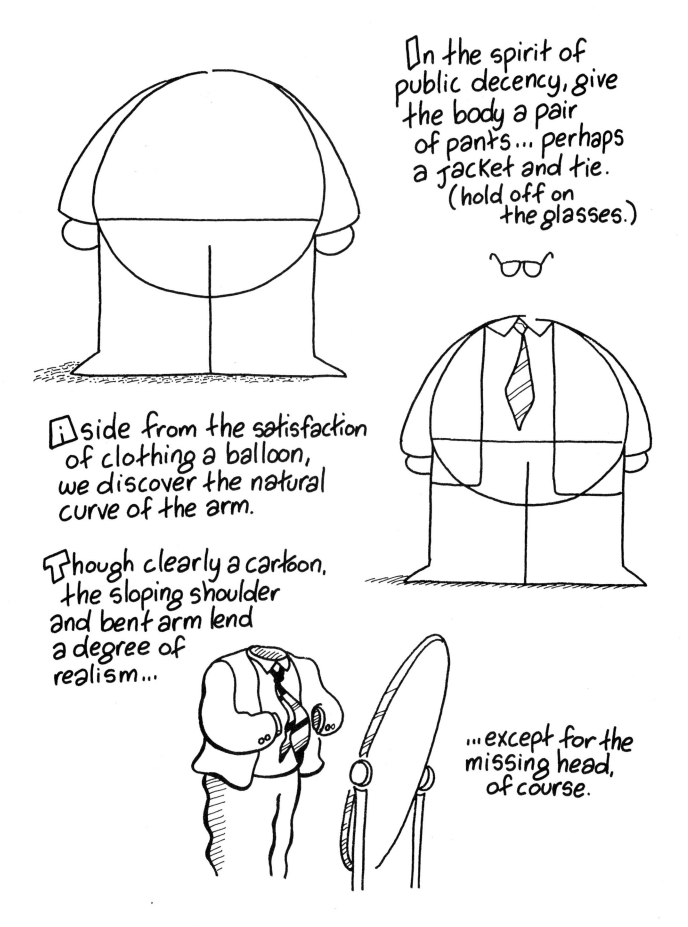

In the spirit of public decency, give the body a pair of pants... perhaps a jacket and tie. (hold off on the glasses.)

Aside from the satisfaction of clothing a balloon, we discover the natural curve of the arm.

Though clearly a cartoon, the sloping shoulder and bent arm lend a degree of realism...

...except for the missing head, of course.

As I said earlier, *no one expects a cartoon to be realistic* — only that it *seem* realistic. A body that stands at ease is one expectation. A body that displays perspective is another.

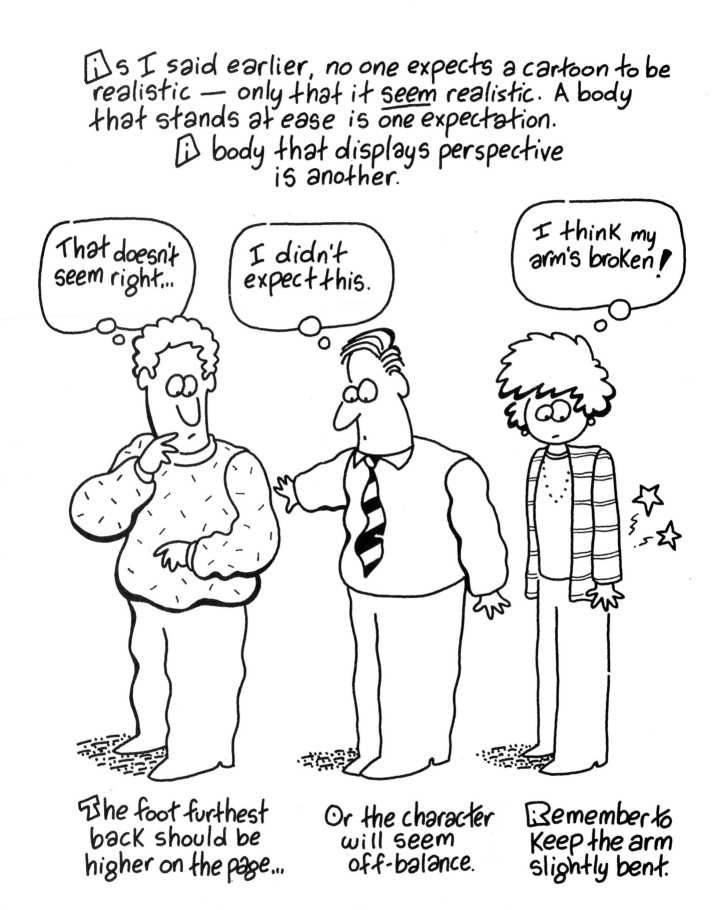

Here's a trick for drawing bodies when you're not entirely certain where to place every line —

Baggy Clothes!

(which, by the way, are often fashionable.)

Even when baggy clothes are in, I'm out.

Baggy garments also remind us that a cartoon body can sport any shape...

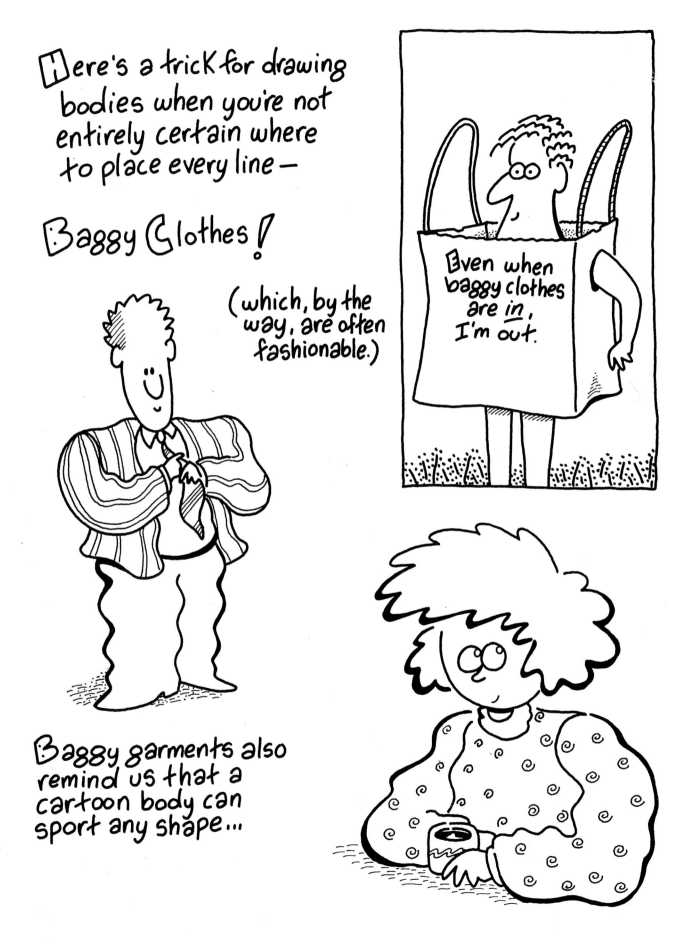

Body Shapes

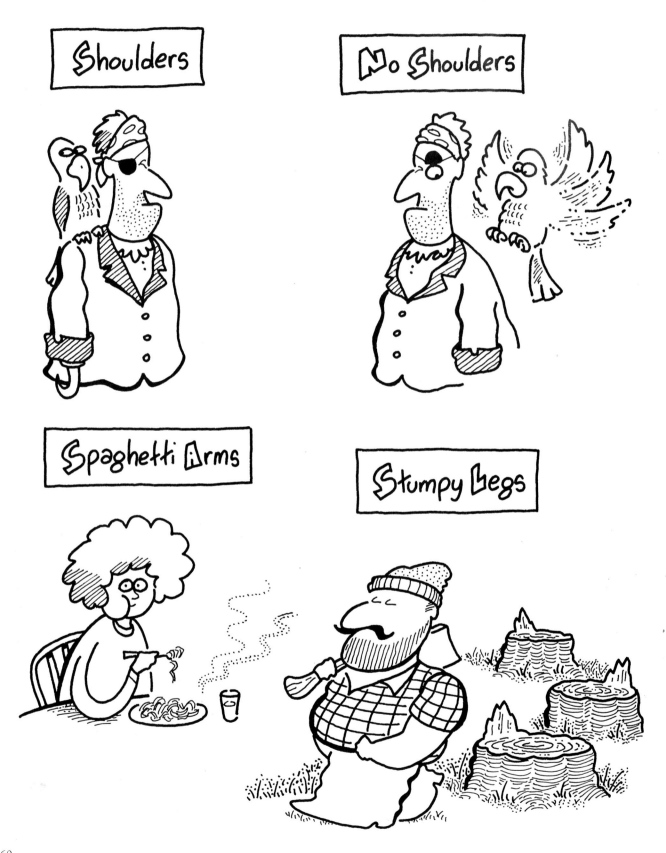

Shoulders

No Shoulders

Spaghetti Arms

Stumpy Legs

You'll naturally abandon the balloon step once you have a feel for body shape...

But it's good to still view your drawing as a balloon in spirit — something you can pump and expand...

Because once you've mastered a character, you'll discover that changing a proportion ...

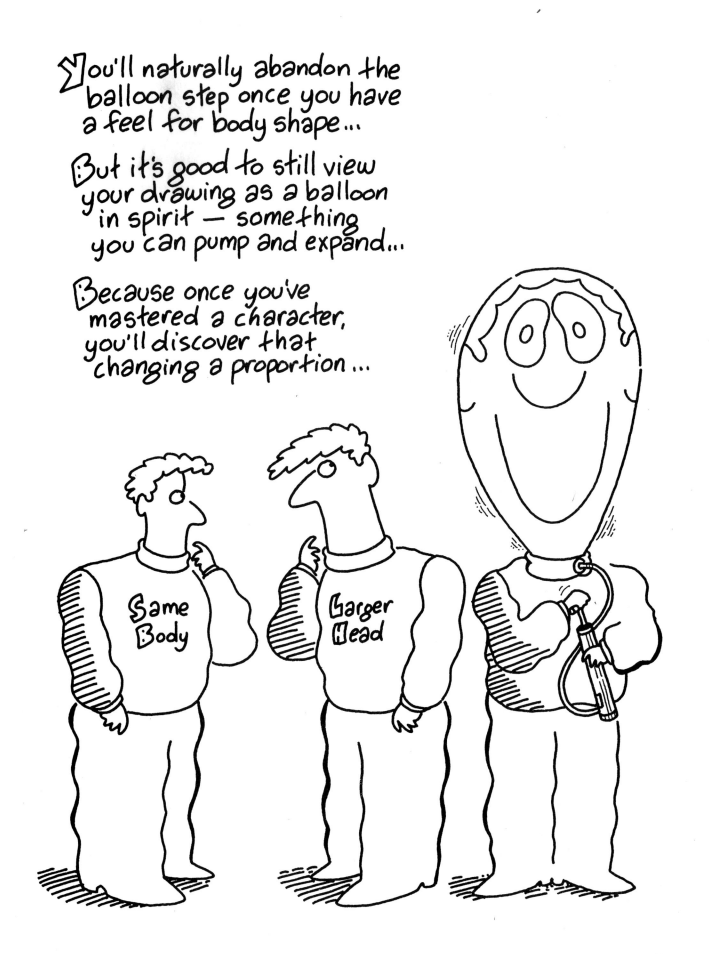

Body in Motion

Eventually, out of boredom or curiosity, the standing around will lead to running around — but realistic motion is tricky to draw, demanding years to perfect.

Fortunately, we're drawing cartoons — they only need to _seem_ realistic (that is, believable) — so this should take just a minute or two.

Find that balloon you discarded. Give it stick figure arms and legs.

Now show it a pin.

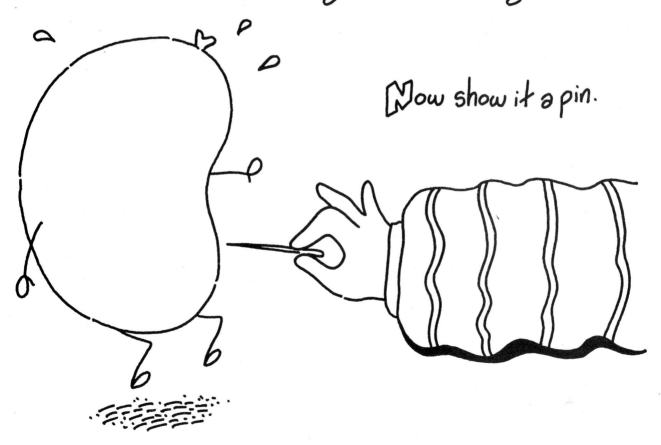

63

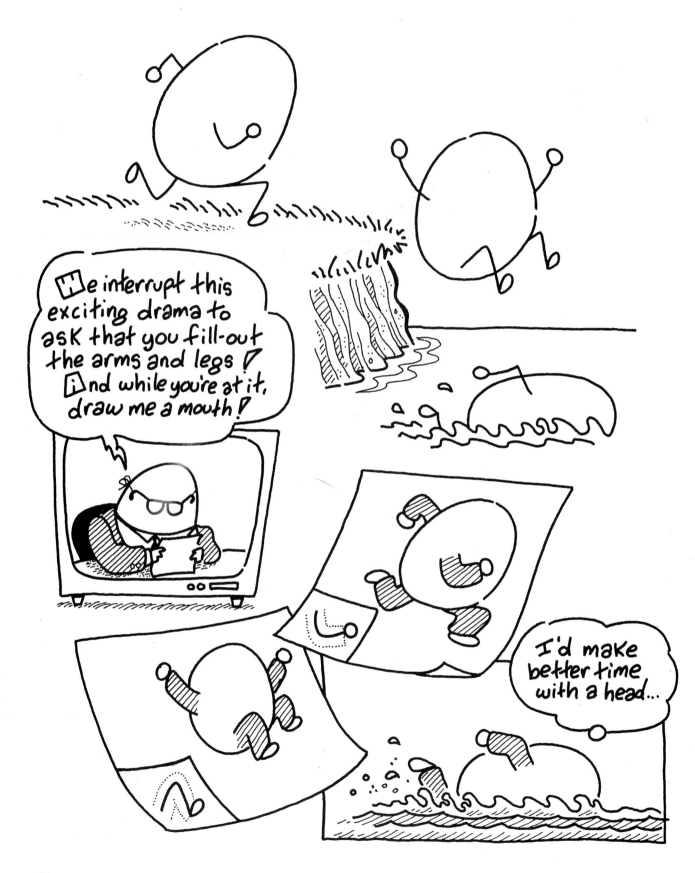

Pop on a head, a pair of pants...

Add a face...

Keep in mind that when the right arm is forward, the right leg is back.

Add a few props.

Note that the dust clouds shrink as they recede...
... creating the illusion of passing time.

Glasses and hats look great in a fall.

After years of drawing, I have a good idea of what a cartoon body in motion looks like (I use a mirror.)

When you move beyond the running balloon stage, simply sketch the character — chances are you'll notice if anything's off. (if anything is off... you're drawing for fun, not illustrating a medical text book.)

Here's a tip for finding the right pose:

Basic Boses

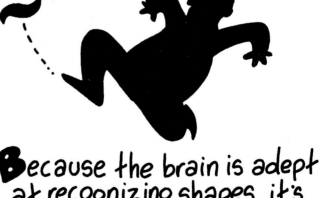

Because the brain is adept at recognizing shapes, it's often easier to spot what's wrong in a silhouette.

More Action

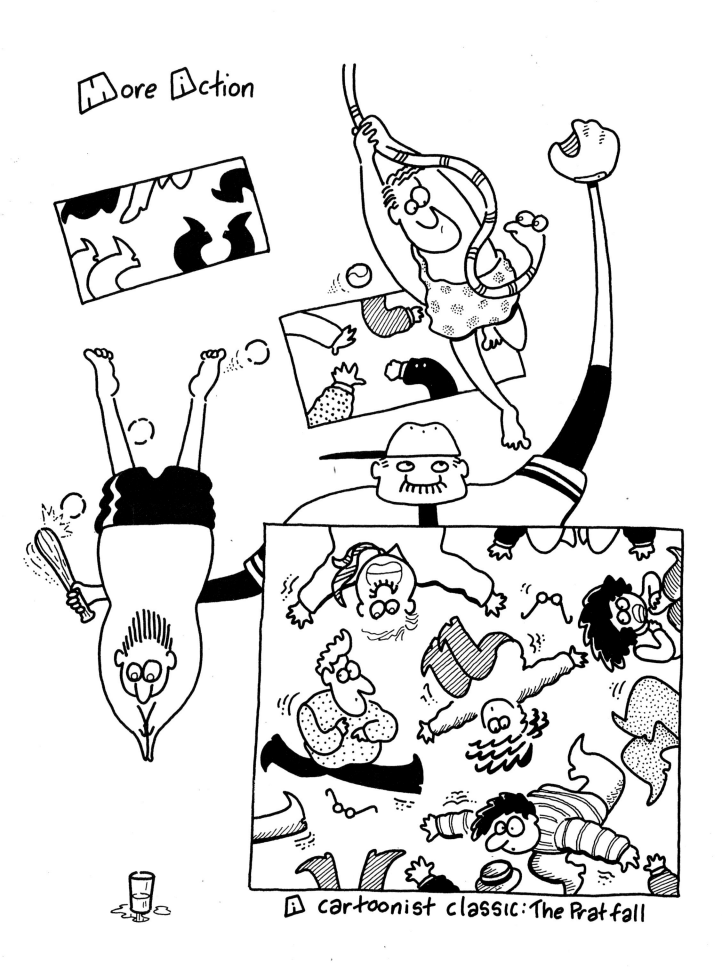

A cartoonist classic: The Pratfall

When Less is More

As with emotions, the physical extremes are easier to convey, more amusing to draw.

But you'll find that the quieter motions— holding a fork, a pen, a mug, a cat— are more valuable.

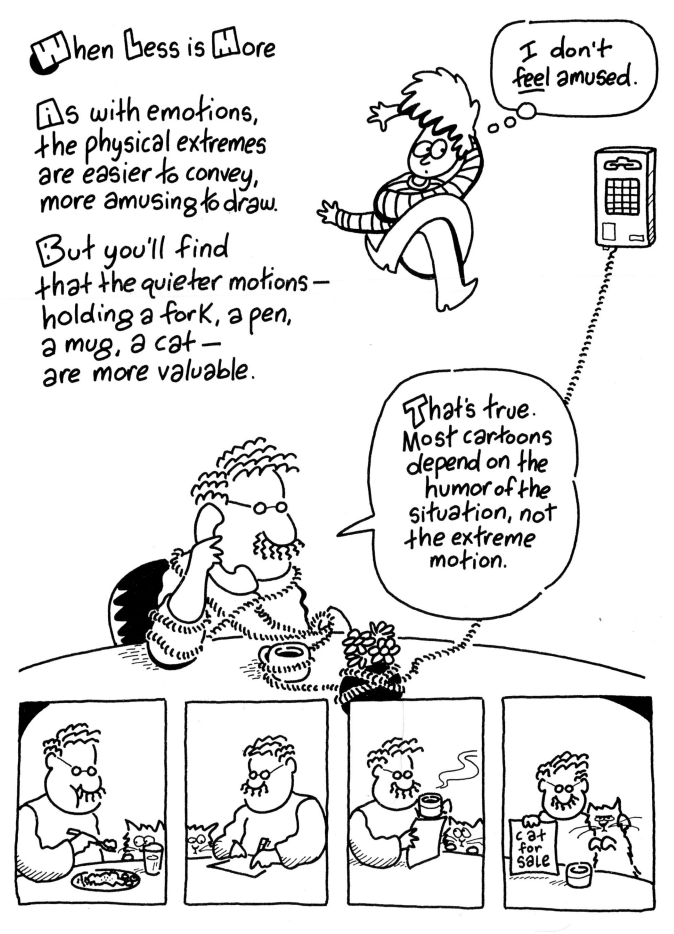

I don't _feel_ amused.

That's true. Most cartoons depend on the humor of the situation, not the extreme motion.

cat for sale

A Show of Hands

The key to quieter motion is the hand (though some gestures, of course, are quite loud.)

Hands? What hands?

You can hide them...

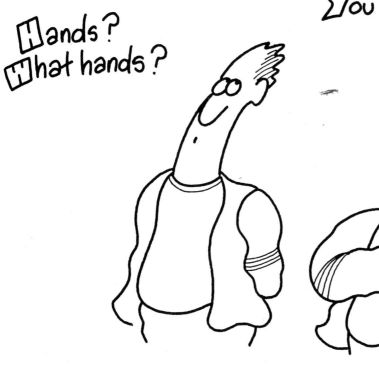

... or show them.

Hiding is fine if the gesture adds to the mood.

But conceal them too often and the reader will wonder what you are hiding (how often do you spend a full day with your hands in your pockets...?)

Catch! BONK!

Hands are as expressive as the face.

Though these five guys share the same expression, their hands tell their own stories...

Of course, hands rarely speak alone...

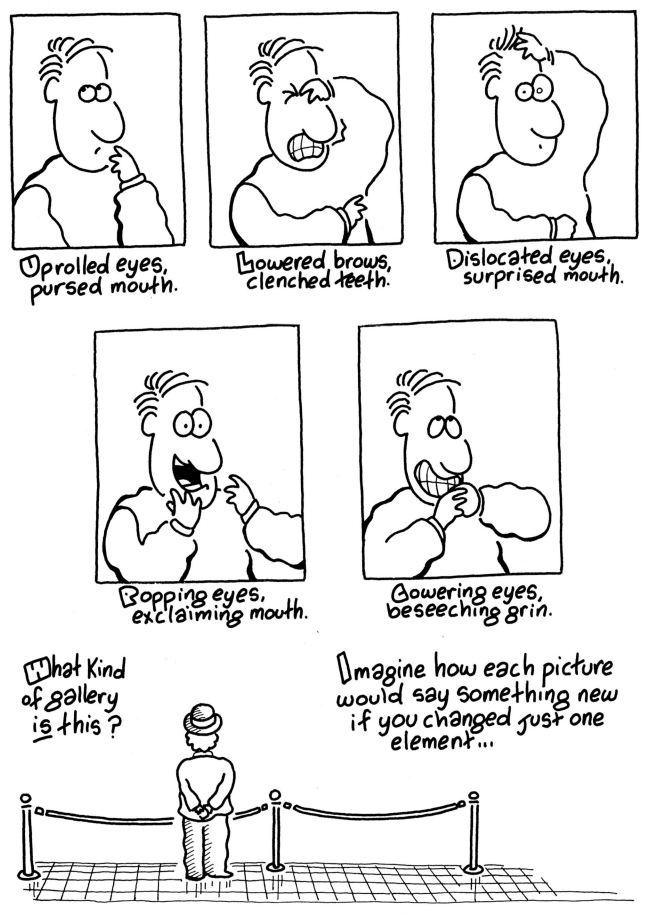

Uprolled eyes, pursed mouth.

Lowered brows, clenched teeth.

Dislocated eyes, surprised mouth.

Popping eyes, exclaiming mouth.

Cowering eyes, beseeching grin.

What Kind of gallery is this?

Imagine how each picture would say something new if you changed just one element...

A cartoon hand is made real by gesture and impression.

For my first impression, I'd like to do a 4-fingered hand, first made popular in early Disney cartoons...

As long as the reader recognizes the gesture, a hand can have 4 fingers or 6 (if you've been counting, you'll note that I favor the 4 fingered variety.)

To give your hands the impression of reality, remember:

1. **F**ingers aren't all the same length.

2. **T**he thumb and pinky of an out-stretched hand share the same angle.

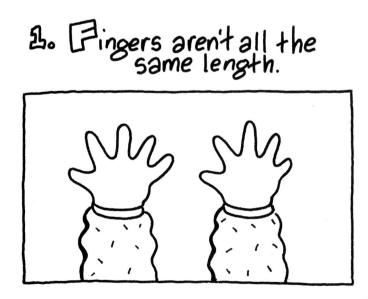

Five Easy Poses

I tell most of my stories with these poses...

Thoughtful

Anticipating

Cross

At ease

Depressed

Gestures

The best way to learn where the fingers go is to study your hand in a mirror...

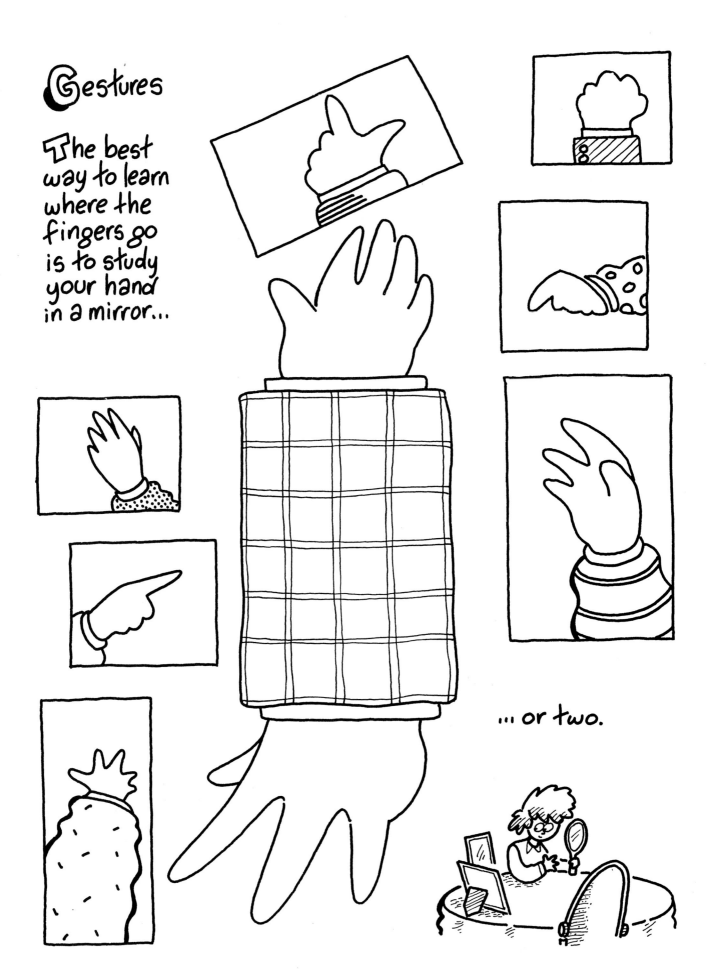

... or two.

Feet (on the other hand...)

Unlike their manual cousins, feet rarely convey emotion.

They do, however, convey **I**nformation.

Pi is the ratio of circumference to diameter... Dickens wrote 'A Christmas Carol' in 1843...

Ask me anything!

They reveal affluence

and leaner times.

They show character

and occupation.

And when bare, they suggest casualness, the sandy relaxation of a day at the beach...

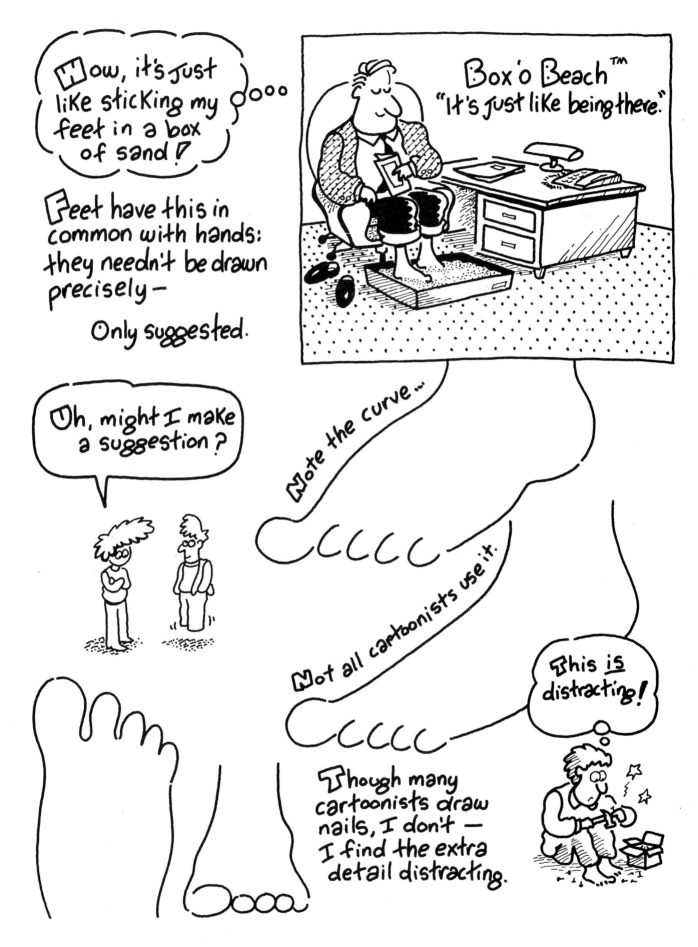

Try these shoes on for size.

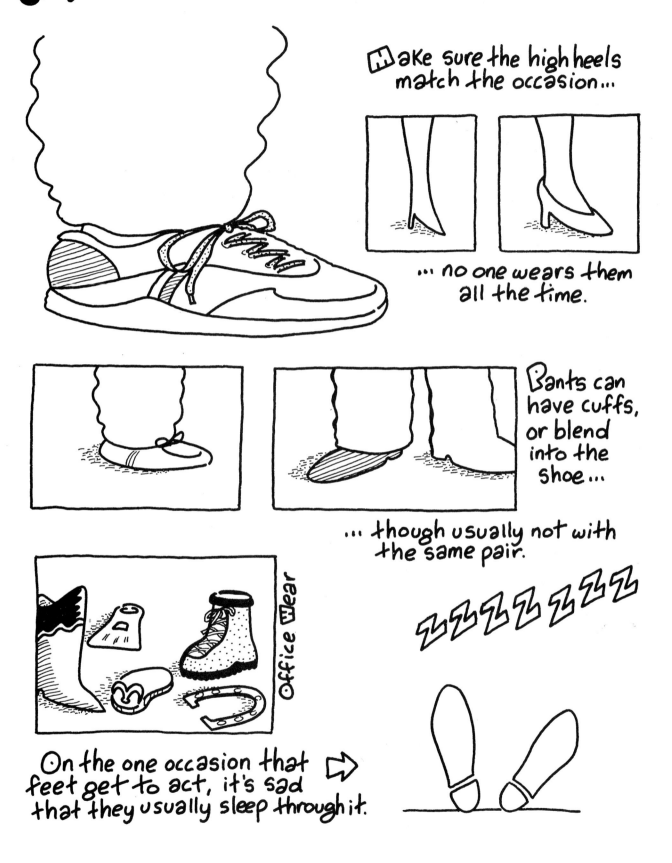

Make sure the high heels match the occasion...

... no one wears them all the time.

Pants can have cuffs, or blend into the shoe...

... though usually not with the same pair.

ZZZZZZ

Office Wear

On the one occasion that feet get to act, it's sad that they usually sleep through it.

Chapter Four

Odds and Ends

We now face the end of the book and I notice something odd: There is no end. Though the back cover will eventually be reached, the study of cartooning is neverending.

Cartooning is like a large box. (I know I said it was like a road trip, but I'm a fickle creature; now it's a box.) The longer I stare into it, the more I see. It's a box of odds and ends that never ends.

Once you're comfortable with your style and ability, it's tempting to suppose that you've seen it all. You might grow complacent. You might adopt a swagger and write a book on the subject. (If so, don't forget to list this book in your bibliography, along with a warm mention in your dedication.) But while writing these pages—pages I wrote because I assured the publisher I knew the topic well—I discovered I knew less than I supposed, and more than I knew.

For example, I realized that I could draw cartoon characters without drawing people (just clothes). I noticed that quivering motion lines didn't suggest shivering (only shaking). In my unlit subconscious, I knew these things. But until I studied them in the light, I couldn't describe them to you. Thanks to the examination, cartooning became a richer experience for me—even more than the royalty. And, with luck, it's become a richer experience for you.

Every once in a while, it's good to upset the box and shake out the contents. With wide eyes, no matter how much you've seen, I guarantee you'll spot something new.

Stereotypes

While it's unwise to judge a person by his or her cover, cartoonists do it all the time.

Cartoons must be quickly recognized —

A reader puzzling over a character's role may miss the point or humor.

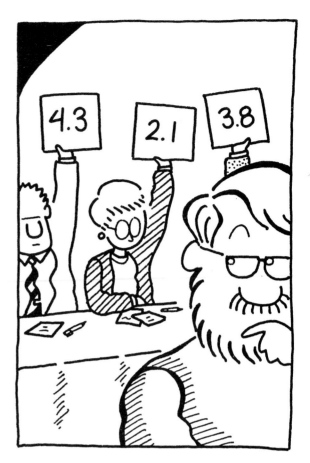

Quiz

Which is the accountant?

a. b. c.

Which is the CEO?

a. b. c.

In real life, any of those characters could be accountants or CEOs (except for the dog, of course.) But imagine the reader's confusion if the cartoonist declined to use the stereotype.

That's true. I would never be an Accountant.

If this cartoon had nothing to do with the CEO's disheveled look (a bad day on Wall St., or the man's eccentric) the reader would waste valuable time wondering about it...

But seat the expected character behind the desk, and the reader moves immediately into the joke.

Mr. Jones, bring me a punchline!

Here's a stereotype to avoid: the woman with exaggerated gender. There are times when this image is appropriate — just as a man of impressive build will occasionally suit the punchline — but don't routinely draw teachers, scientists, plumbers, and so on, in the guise of a model.

The point of a cartoon is usually the idea, the joke, not the character's glossy and fashionable image. That's why most characters have an all-purpose, more-or-less typical demeanor.

Demonstration 1.

You could use this generic face in hundreds of situations. The reader would accept it and move on to the rest of the cartoon.

But cast a face and form that's at the far end of a bell curve, and the reader will pause, expecting the cartoon to be about the man's atypical appearance.

Treat female characters with the same respect shown to male characters...

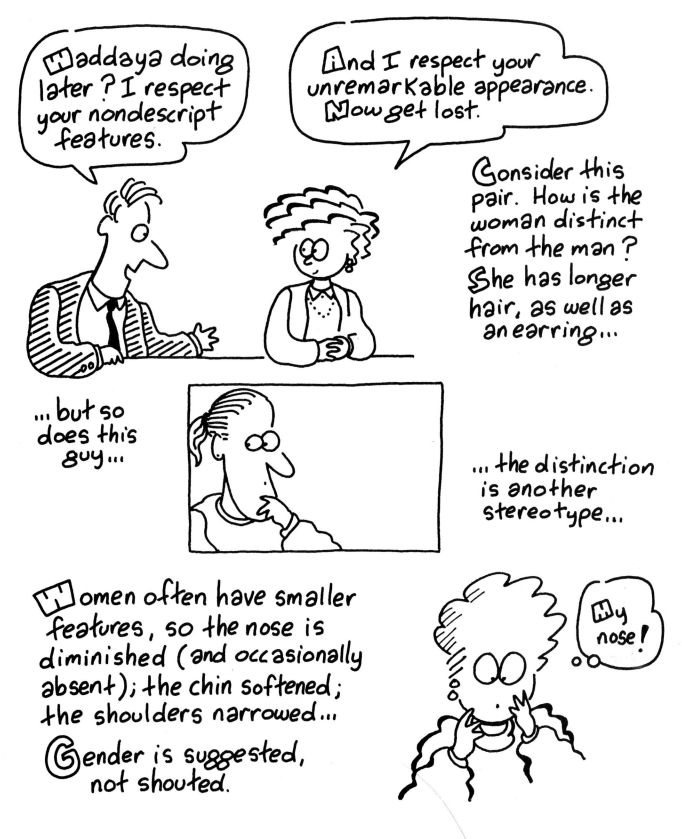

Waddaya doing later? I respect your nondescript features.

And I respect your unremarkable appearance. Now get lost.

Consider this pair. How is the woman distinct from the man? She has longer hair, as well as an earring...

...but so does this guy...

...the distinction is another stereotype...

Women often have smaller features, so the nose is diminished (and occasionally absent); the chin softened; the shoulders narrowed...

Gender is suggested, not shouted.

My nose!

Should you find yourself drawing a woman below the shoulders, follow the same restraint.

Most women — and most men — are of modest proportion.

And that's especially true for those characters with a joke to tell.

Demonstration 2.

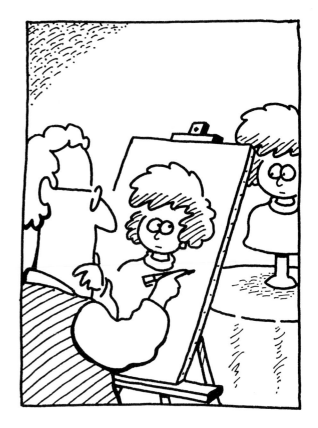

This mild guy could appear in most cartoons; he wouldn't distract the reader from the punchline.

This gentleman, however, is too conspicuous to ignore. Any cartoon he occupies will need to incorprate his broad shoulders into the joke.

Dressing Up

It might not be true that clothes make a man or woman, but they can certainly make a cartoon.

Clothes are so vital, you could almost dispense with the people...

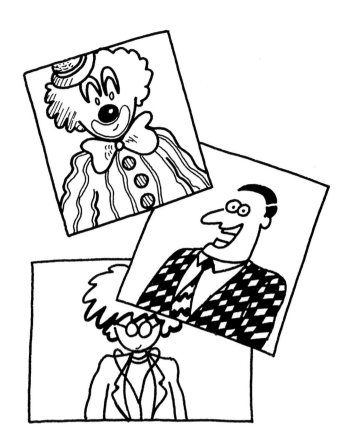

... they reveal occupation, avocation, personality...

... another good reason to favor the nondescript character...

Let the clothes set the scene, without the distraction of an over-the-top and out of the norm style of body.

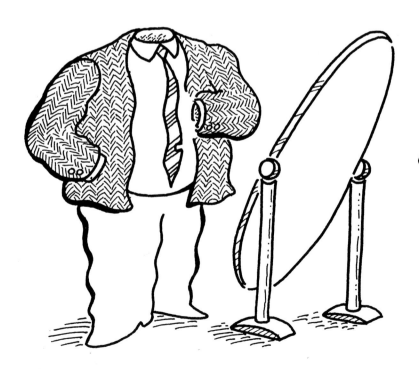

First Impressions

Clothing is sewn from simple and familiar patterns — Accessories are generic and instantly recognizable.

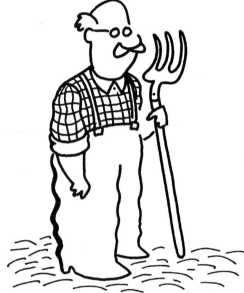

The pitchfork and overalls make a farmer.

An accurate first impression depends on a few details:

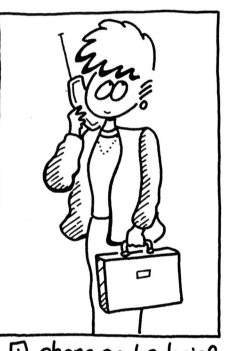

A phone and a briefcase make a business person.

The headband and leotard make an instructor.

A loud shirt and camera make a tourist.

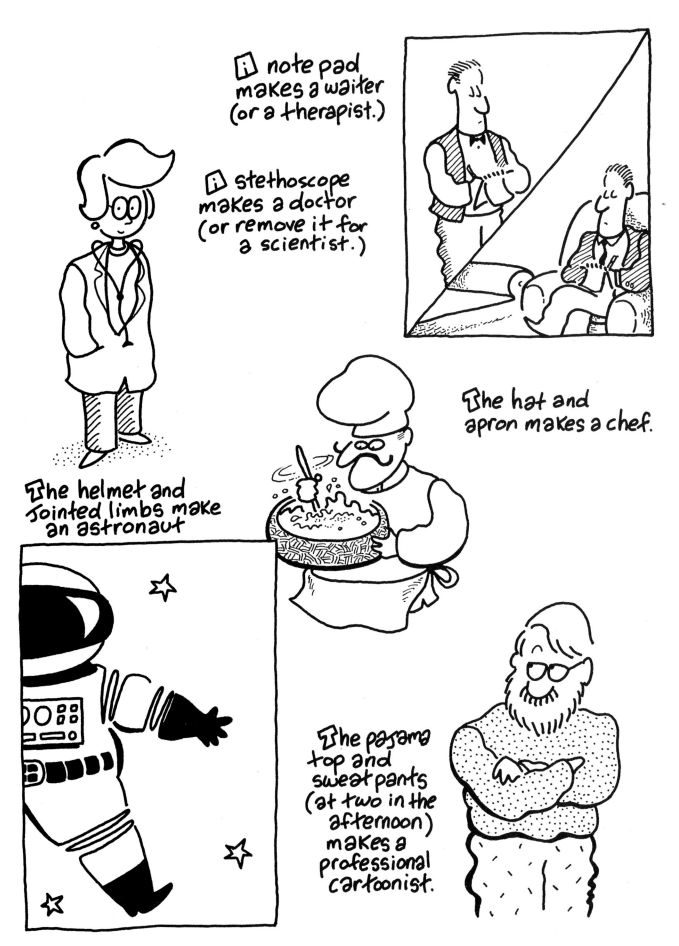

A note pad makes a waiter (or a therapist.)

A stethoscope makes a doctor (or remove it for a scientist.)

The hat and apron makes a chef.

The helmet and jointed limbs make an astronaut

The pajama top and sweat pants (at two in the afternoon) makes a professional cartoonist.

Stage Dressing

Setting is another stereotype. If clothes are the costume, then the background is the stage...

In fact, it sets the stage, revealing situation and premise.

2b, or not 2b... Whether 'tis nobler to draw with a pencil...

For example, imagine a man without clothes. The setting can expose what the clothes would have shown...

... though he lacks a stethoscope, you know it's a doctor's office...

toss out the scale and drag in a couch and the office belongs to a psychiatrist.

Doctor

.. Needs a doctor

Keep the same desk, but install richer carpet and wainscoting, and you have a naked executive who should probably close the drapes.

Background That's in the Foreground

Back to Nature

I draw foliage in the same fashion I draw hair...

...loosely, creating my own styles.

Trees often lean

Because of their size, I rarely draw the full tree — a partial view is ideal for framing a scene.

I bet I could get 3000 frames out of that tree...

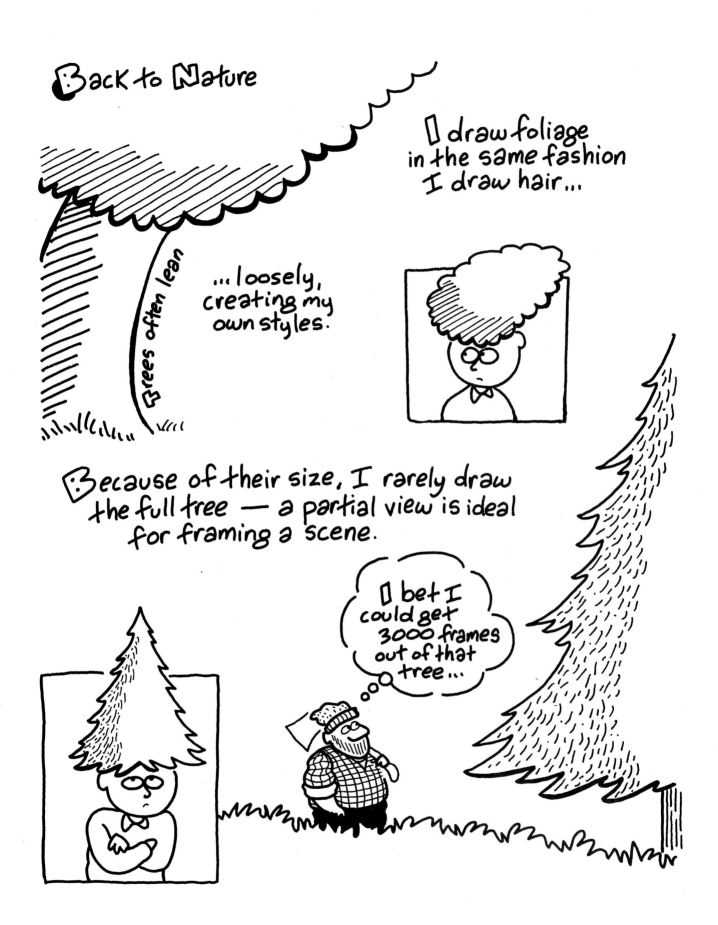

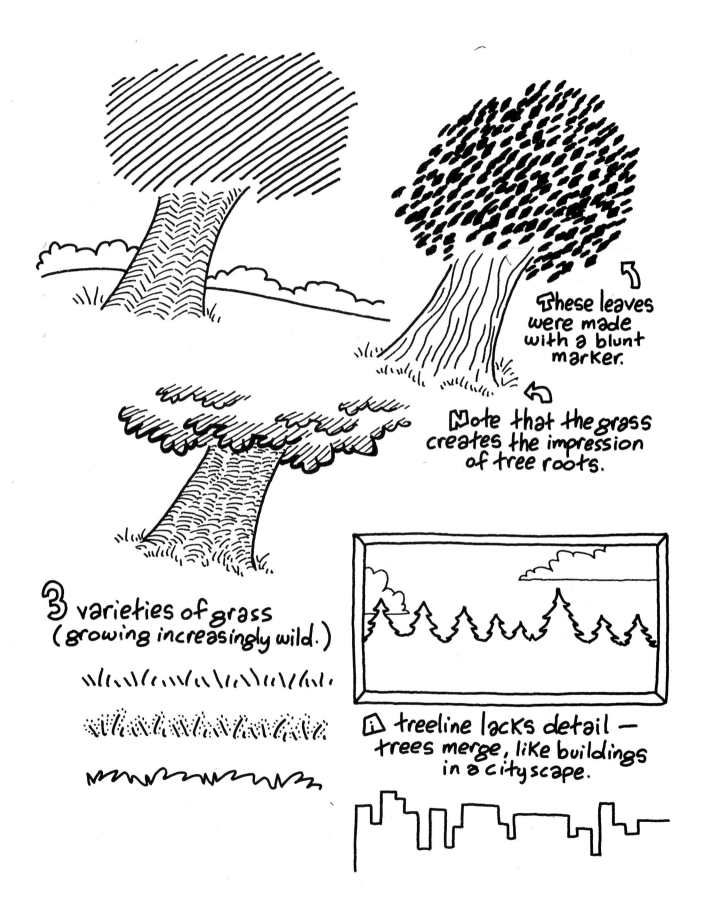

These leaves were made with a blunt marker.

Note that the grass creates the impression of tree roots.

3 varieties of grass (growing increasingly wild.)

ⓘ treeline lacks detail — trees merge, like buildings in a cityscape.

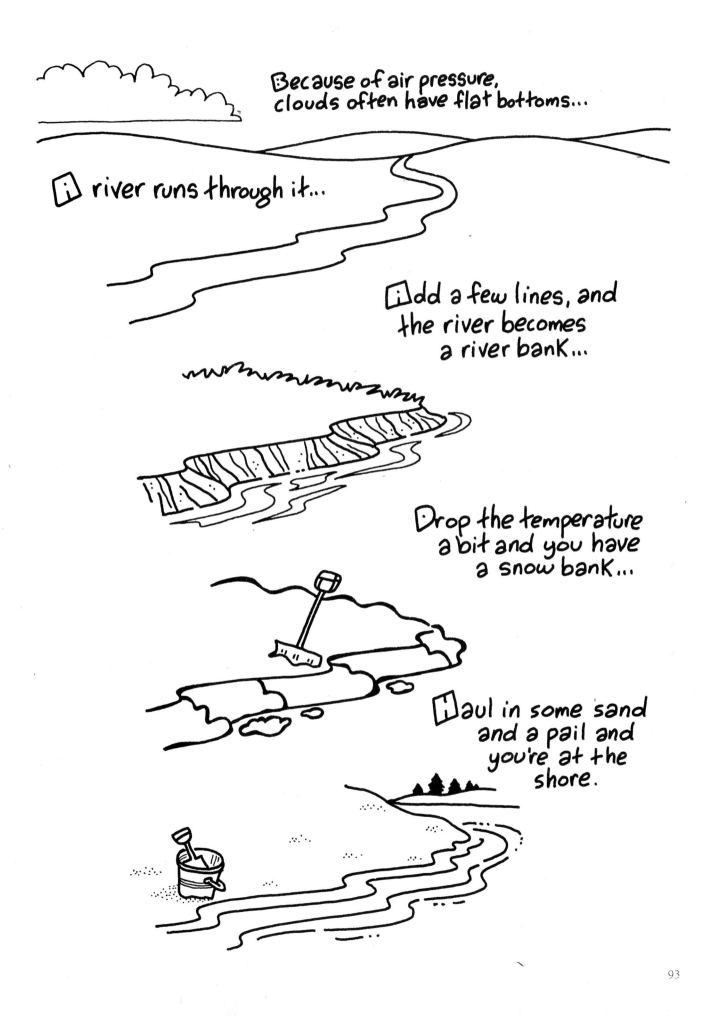

Because of air pressure, clouds often have flat bottoms...

A river runs through it...

Add a few lines, and the river becomes a river bank...

Drop the temperature a bit and you have a snow bank...

Haul in some sand and a pail and you're at the shore.

Four Day Forecast

Wind

Though not everyone wears a tie, they're great for showing wind.

Other windy signs: the hair and rippling pants... the swaying grass and airborne debris... the squinting face...

Scarves are also dramatic props, along with glasses, hats, and anything else that's not nailed down.

Rain

It often falls at a wind-blown slant, a cascade of lines that suggest racing drops. Note that the shirt's tone is lighter in the rain, as if obscured by the humid atmosphere.

The shoulders are hunched, the hair flat, her face scowling: she _acts_ wet.

Snow

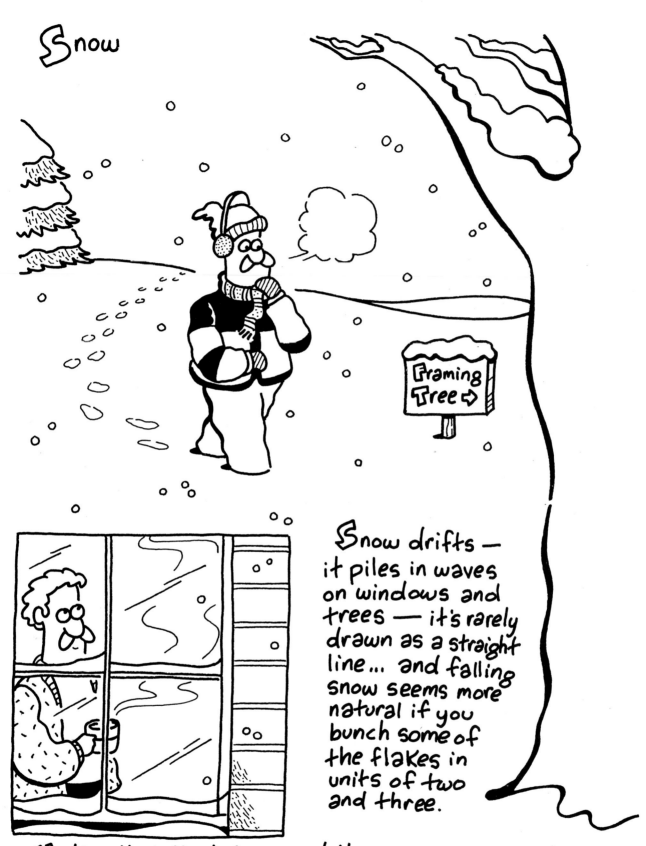

Snow drifts — it piles in waves on windows and trees — it's rarely drawn as a straight line... and falling snow seems more natural if you bunch some of the flakes in units of two and three.

Notice that the hole around the man's ankles is a bit wider than his leg... and the snow at the base of the tree and sign has settled to form a shallow depression.

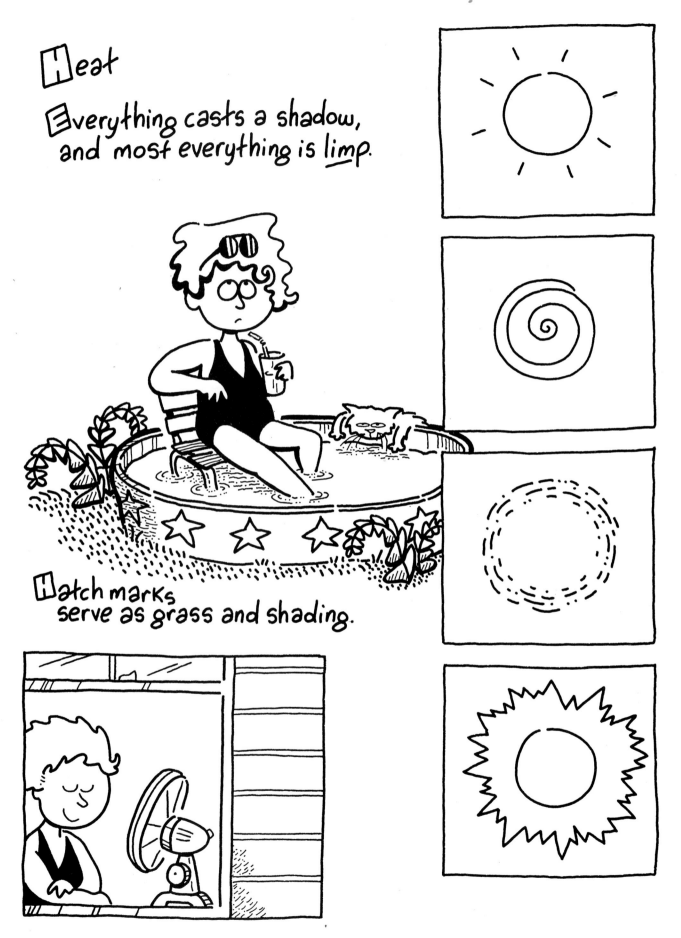

Heat

Everything casts a shadow,
and most everything is <u>limp</u>.

Hatch marks
serve as grass and shading.

Animal Nature

There are three ways to draw an animal:

Upright on two legs...

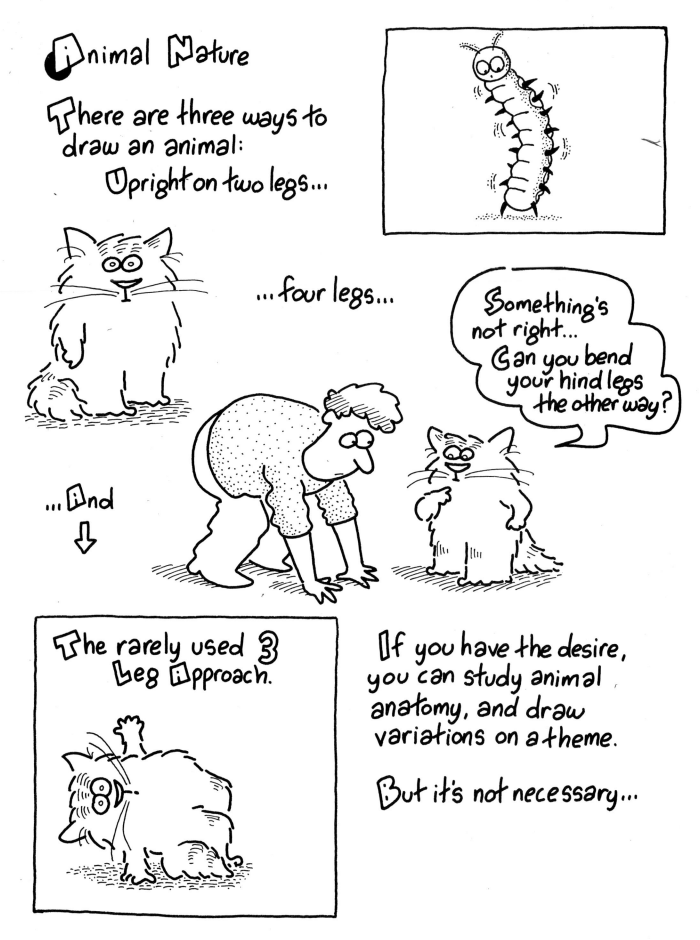

...four legs...

Something's not right... Can you bend your hind legs the other way?

...And ⬇

The rarely used **3** Leg Approach.

If you have the desire, you can study animal anatomy, and draw variations on a theme.

But it's not necessary...

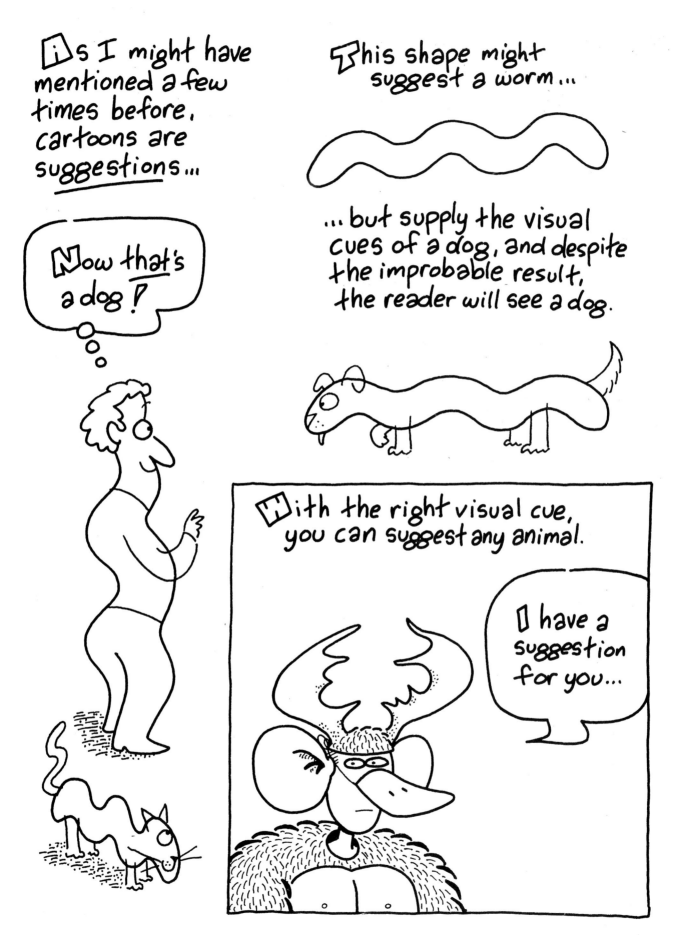

Shared Cues

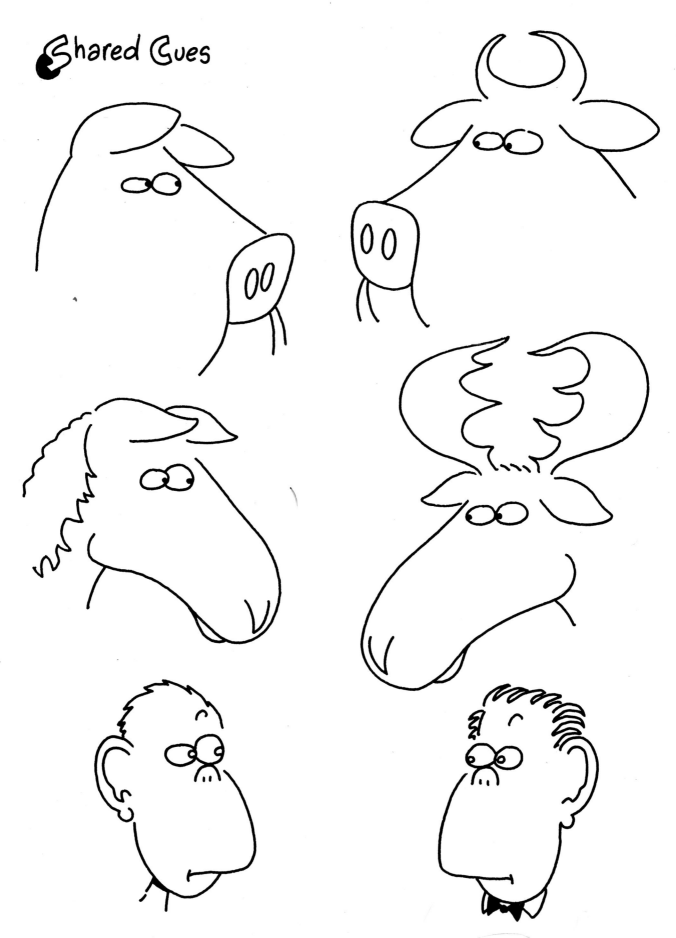

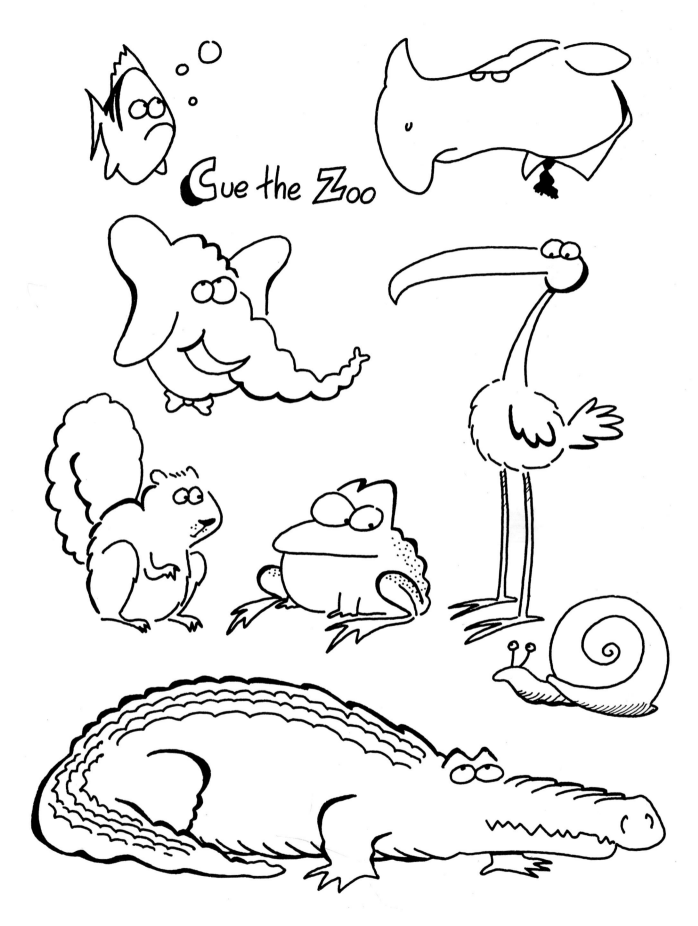

Cue the Zoo

An Autobiographical Confession

Though my work graces magazines and greeting cards, I still have my doubts.

Cartoonists are performers. Much of our success depends on the audience. Will it yawn or applaud? With every drawing, we're taking a chance, risking boos or hurrahs.

If you're feeling the slightest doubt, you're in good company.

Remember:
Art demands a challenge,
and a challenge,
by definition,
demands some uncertainty...

You're facing that challenge.

I'd be surprised if you weren't a little apprehensive about yourself and the audience...

After all— you're a cartoonist.

hading

Whatever you draw, you'll always have an opportunity for shading...

...not that you should... many cartoonists are content with the spare elegance of line art — they believe that less is more, and probably enjoy plain toast and black coffee.

It takes a strong confidence to find satisfaction in such an economical drawing...

...and since I lack that confidence, here are my 4 reasons for shading:

> **I**t lends interest to the drawing.
> **I**t contributes to the mood.
> **I**t directs the reader's eye to key elements.
> **I**t helps to compensate for my suspicion that my art is occasionally lacking in some way...

6 Degrees of Shade

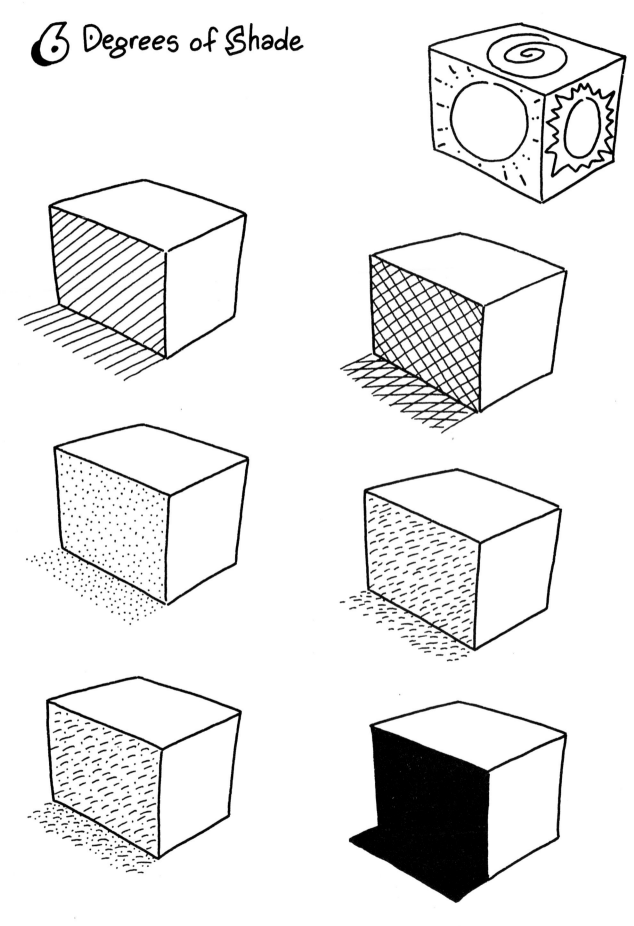

A drawing can benefit from shading, but _not_ if used helter-skelter. Consider the value of each style...

Does the pattern suggest a texture, a mood, a place?

For example, to my eyes, dots convey the feel of sweaters — and shading is created when I pack the dots along an edge.

Another, more subtle shading, is the thick and thin line art — the lines are fatter on the shady side of the character.

The pants are dressed with coarse hatching — a bold graphic look I'll use sparingly (the pattern's heft might overwhelm the rest of the drawing.)

The ground shadow is a random collection of dots and dashes. Lacking a distinct edge, or uniform tone, the shadow seems more natural — to me, at least.

The shading you choose is a part of your style.

Some artists prefer this...

Others prefer a broken line...

And as I said a few pages back, some artists possess such steely resolve that they prefer no... shading... at... all...

Are you sure you don't want to throw on a little shading before we go out?

I'm fine, thanks.

3 more shades
to consider:

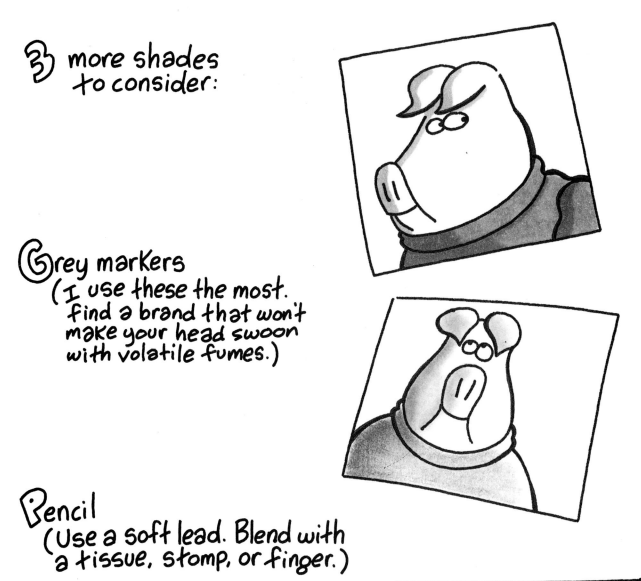

Grey markers
(I use these the most.
find a brand that won't
make your head swoon
with volatile fumes.)

Pencil
(Use a soft lead. Blend with
a tissue, stomp, or finger.)

Ink wash
(You'll need a fairly heavy
paper to resist buckling.
Use black watercolor or
diluted ink. Some artists
draw with water-soluble ink
then go over it with a wet brush.)

In the Mood for Shade

Fade to Black
(Shedding light on graduated greys.)

No matter the style of shading — hatching, cross-hatching, or dots — the marks grow denser as they recede from the light.

Shading is a matter of layers. You begin with a light one...

...then add a second layer at the half-way point. Try not to over-lap the lines.

The final layer settles in the outer third.

If you use a marker, work in reverse — begin with your darkest grey...

...then sweep over it with a lighter grey — this softens the transition between shades.

Speed Traps

There are two speeds in cartooning—

Be sure you don't fall into the trap of drawing at the wrong speed.

Let's consider the first:

Fast — this is ideal for sketching concepts...

You don't worry about running off the road because you're following your own directions, racing wherever you please, chasing ideas and layouts...

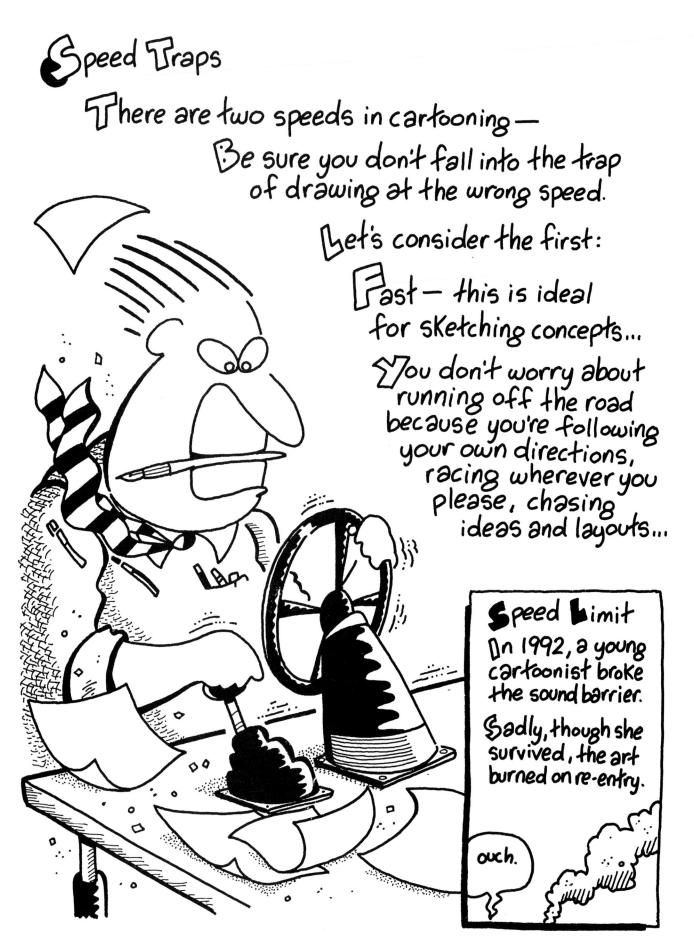

Speed Limit

In 1992, a young cartoonist broke the sound barrier.

Sadly, though she survived, the art burned on re-entry.

ouch.

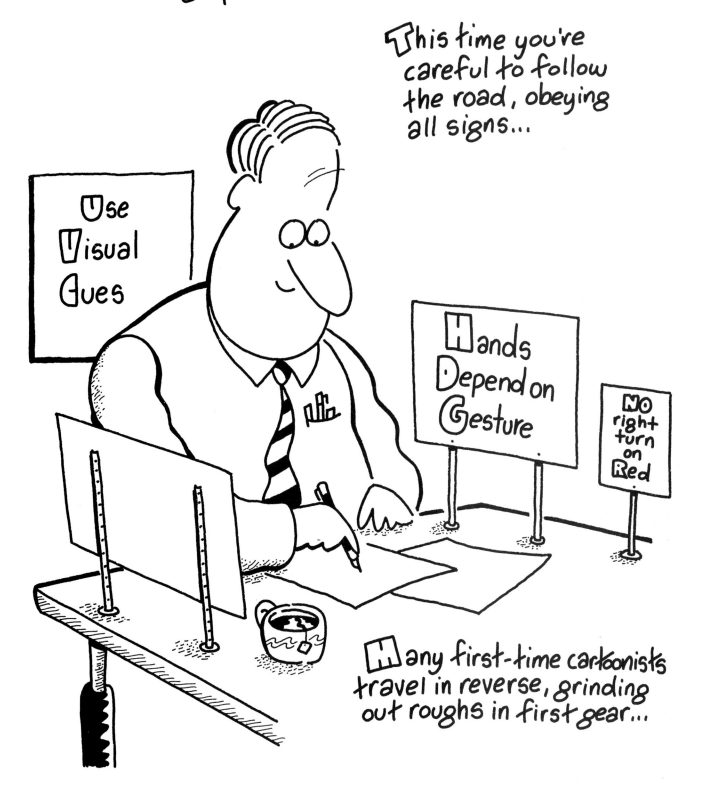

Slow — that is, _methodical_ — is the perfect cruising speed for finished art...

This time you're careful to follow the road, obeying all signs...

Use Visual Cues

Hands Depend on Gesture

NO right turn on Red

Many first-time cartoonists travel in reverse, grinding out roughs in first gear...

... or, to switch metaphors, driving the nib into the paper with a plow's conviction. This cramps the hand and exhausts the artist...

But a rough should be exhilarating, dynamic, and live up to its name...

So work fast, have fun, and keep it <u>rough</u>.

A "fun" rough.
Elapsed time: 4 seconds.

A "more methodical but working hard to seem as fun" finish. Elapsed time: 10 minutes.

Legal Disclaimer

My attorney has advised me to state that your mileage may vary, and that there is no typical elapsed time.

There are fine cartoonists who sketch slowly and race through the finish (for a spontaneous appearance), while others spend hours, even days, on a glorious finish.

When I suggest a drawing speed, it is — like so much in cartooning — a suggestion. (read the preceding three times for that triplicate experience.)

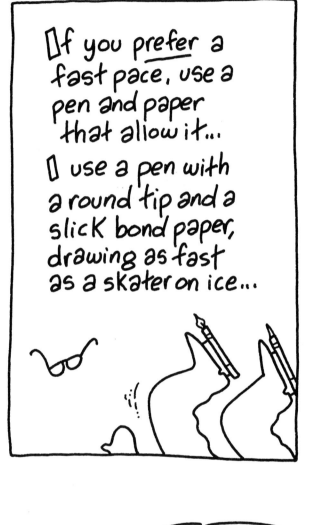

If you prefer a fast pace, use a pen and paper that allow it...

I use a pen with a round tip and a slick bond paper, drawing as fast as a skater on ice...

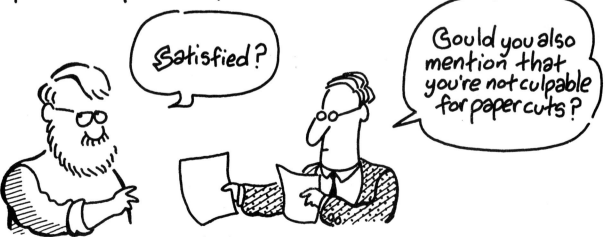

Satisfied?

Could you also mention that you're not culpable for paper cuts?

Low Budget Special Effects

To heighten the illusion of motion and things barely glimpsed, draw broken lines and multiple images...

(the shadow makes it clear that the man isn't on his knees.)

With the addition of <u>swivel</u> lines...

...this gentleman ⇨ blends in a crowd.

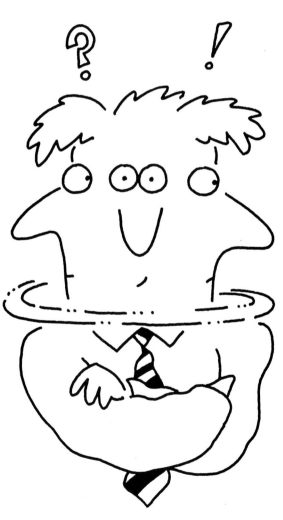

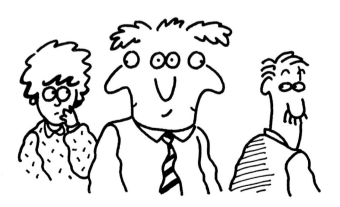

But for convincing animation, motion lines aren't always enough — this character wouldn't be shivering without the clenched teeth, the hunched shoulders, the raw nose...

Earth-quake?

Motion can be a string of swirling dots...

... lines and dashes...

... or a bit of everything under the sun.

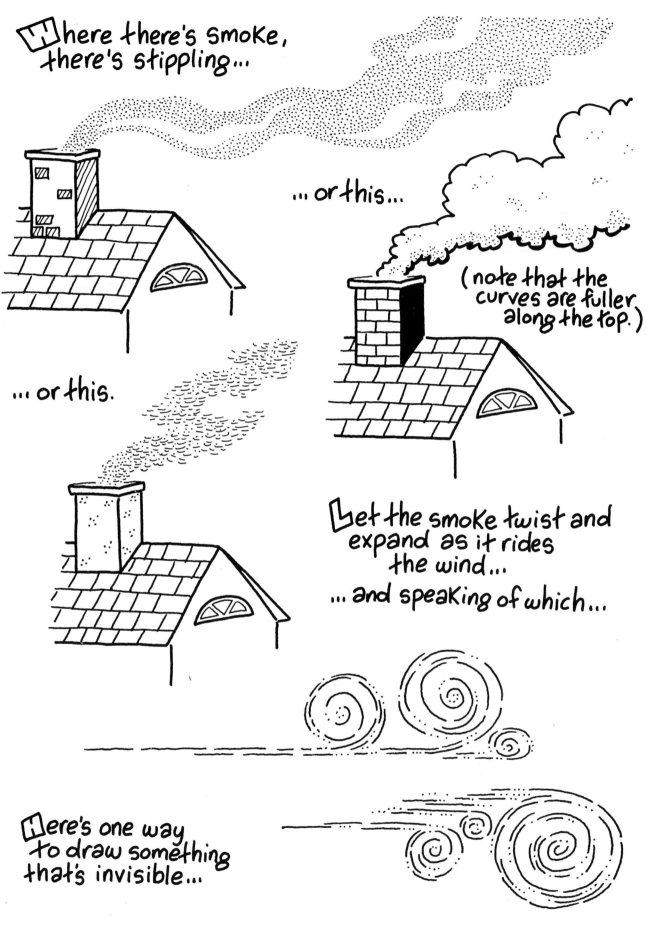

Here's another ⇧

In cartoons, an aroma can be seen, for good...

... and ill.

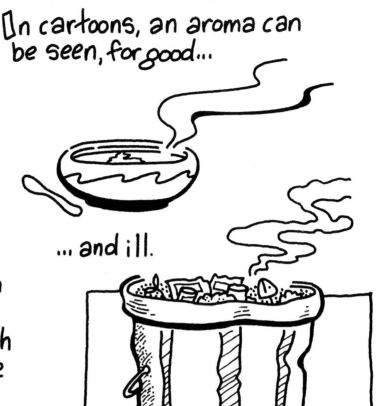

I distinguish between the two by giving the pleasing scent a smooth ribbon of steam, while the stench is ragged.

Another venting of steam which is never seen but often drawn.

Just as smoke and steam expands with elevation, bubbles swell when they rise—

Air, soap... even the chain of bubbles that anchor thought balloons.

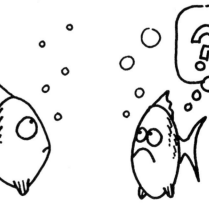

117

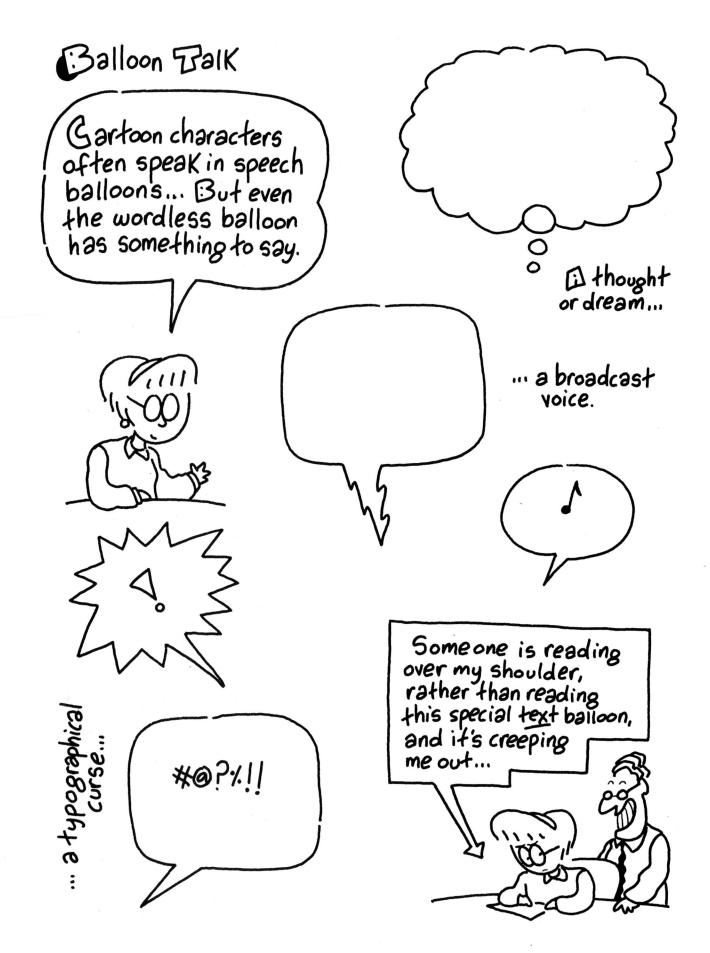

A Word on Lettering

Many books announce the font of the text, so here's mine: Mark Heath Casual. It might seem that I've scrawled the words, but each letter is actually a deliberate calligraphy. In a cartoon with words, the lettering reflects the artist's style, allowing it to blend with the drawing.

Points to consider:

Cartoon lettering is often compact — tight becomes tight ... but beware of unintentional spelling (when letters are too close.) For example, a compressed "old" can look "dd" or "old..." a language few will recognize.

IT'S EASIER TO STACK SENTENCES IN CAPS, but lowercase is fine if you take care to avoid tangles.

If you choose lower-case, substitute a few letters with a form you rarely use — I switch an a for an a, and a g for a g. This alteration slows my writing a bit —
— a reminder that lettering should be more pleasing to the eye than a scribbled phone message.

Which reminds me: The Muse called. On with the book...

The Imperfect Copy

As this book demonstrates, cartoonists learn by copying. But not in the manner of a copy machine.

My style is a loose copy of many cartoonists — a shoe here, a nose there — and the style that settles out from all of these bits is my own.

To avoid the precise copy, copy widely. Consider the work of every cartoonist you admire...

... and then ask yourself: What is it you admire? Chances are, you're drawn to the elements that remind you of no one else.

Let others admire you for the same reason.

In art, the imperfect copy is the perfect copy.

Stamp of Approval

If you'd like an encouraging word from a cartoonist, write a letter. Send it to the magazine or publisher that carries the artist's work and they'll pass it on.

I'll be greatly surprised if you _don't get_ a reply.

It might take awhile, but no matter the success (and occasionally the fame) no cartoonist forgets the strange and peculiar joy of first drawing a cartoon ...

... and it's a pleasure to help those who are feeling that joy for the first time.

And while a phone call to a favorite cartoonist has its charms, an even better use of the phone line — one that combines the alacrity of a call with the courtesy of a letter — is the internet.

Cartoonists are migrating online, erasing the usual solitude with e-mail and web pages... one minute you're the only person you know with a love for cartoons...

... and in the next you discover that you're one of thousands.

Just as a cartoon needs an audience, a cartoonist needs an audience of his or her peers.

Sights You Might Have Missed Along the Way

While we drove through the lessons, we passed certain drawings that have more to teach us.

Page 10:
I had trouble drawing the woman's pant leg. Rather than white it out or start over, I colored the leg black and altered the shape. As I mentioned elsewhere, it's often easier to see what looks right when it's a silhouette.

Page 12:
I added solid black to the art store drawing because there was an abundance of stipple and hatch marks, perhaps too much. The solid areas are easier on the reader's eye, reducing the chaos of the picture.

Page 17:
Note the curved lines on the couch. The pattern adds dimension to the furniture.

Page 25:
Along the rim of the bar you'll see diagonal lines. I use these to suggest wood even though an actual wood grain wouldn't run that way.

Page 26:
I left white space around the nose anchor. This highlights the joke and attracts the reader's eye. In other cartoons, you'll notice that this nimbus of white space surrounds important characters. This allows the character to stand out from the background.

Page 49:
An exception to the rule. Randy Glasbergen (author of several books on cartooning) avoids this rigor mortis with a style that strikes me as round and organic; a ball seems round regardless of the angle. Further proof that talent and skill can circumvent any rule.

Page 62:
The circle pattern on the carpet suggests perspective. The ovals are increasingly flatter as they recede from the reader.

Page 63:
Here's a lesson in laziness and reward. The hand holding the pin was a minor triumph for me. Though I've drawn thousands of cartoons, this was a new pose. I tried to fake it, and I succeeded: It looked genuinely fake. I finally drew the hand by studying my own, and now I can draw the pose without thinking about it, or worse, avoiding the need to use it. For all I know, I've unconsciously rejected cartoon ideas that demanded this gesture. While I've emphasized that you can draw a cartoon without studying anatomy, it's also true that the more you can draw, the more options you'll have.

Page 84:
The dots in the man's jacket seem random, but I actually placed them in neat rows. The diagonal lines break up the pattern.

Page 88:
I created the effect of a spotlight by leaving the white space around the actor, following the folds of the curtain. For anything less than solid black shading, I try to avoid a hard edge.

Page 89:
Take a look at the couch with the coffee table and the extremely busy carpet. After I drew the pattern, I swallowed aspirin and considered ripping up the flooring. It clashed with the drawing. It pained the eye. But since we learn from my mistakes, I left it for your disapproval. Style and aesthetics can determine when detail becomes excessive, but this time it's pure biophysics: too much information for the brain to handle. As a rule, if you find your eye skittering over a drawing, struggling to take it all in, you've drawn too much detail.

Page 91:
I rarely add texture marks to the whole tree (or as much of the tree as I've shown). I use shading to suggest the otherwise undisclosed texture.

Page 93:
Another example of suggesting the total texture. Rather than cover the beach with hundreds of dots, I applied just a few, letting the reader imagine the rest. As for shading, I like to use the pattern at hand. Sand is composed of dots, so the shading is concentrated dots (rather than tiny lines). Grass is grown from hatching, so the shading is tighter hatching (rather than tiny dots).

Page 95:
Calm puddles offer straight reflection lines, while the agitated puddles offer ripples and waves.

Page 102:
Notice how the jagged border between white and black emphasizes this couple's explosive trauma as they realize they may be unable to draw cartoons.

Page 110:
I drew little of the driver's left arm. If I'd drawn more, it might have cluttered the view of the steering wheel. When you draw a busy scene, feel free to leave out areas that might block or distract the reader's eye.

Page 112:
Take a close look at the runners on the plow. Notice anything amiss? To honor the perspective, the tip of the runner furthest back should extend more to the left, beyond the runner in the forefront. I didn't notice this mistake until the drawing was finished and decided to leave it as a subtle test. Remember, even the simplest cartoon should obey basic perspective.

Off-Road Travel

Now that you've traveled this far, where's the next stop? This is where you install a bolder engine, fatter tires and lunge off the main road and explore new trails.

As the title of this series promises, drawing pictures is the first step. But if you'd like to go further, the next step is *writing*. With the right books and a thoughtful consideration of artists you admire, you can learn about misdirection and irony and delayed punch lines, verbal clichés and puns, and concise captions. When you can write a cartoon, your graduation is complete. You've become a cartoonist in the grandest sense.

Still another step is marketing your work. If your cartoons are based on concepts and slants, you can beguile greeting card companies and magazines, comic book publishers and ad agencies, licensors and web page designers, syndicates and newspapers.

And when you're not drawing, writing or marketing, you can relax and study the history of cartooning. Some historians feel that the prehistoric scrape of charcoal on a cave wall was the first cartoon. Others credit Renaissance painters, Victorian cartoonists and the comic strip artists at the turn of the century. Whichever mark led to the rest, it's good to know that, despite the solitude of cartooning, we're in good company.

You can do all of this or none of it. Cartooning is an attitude, a way of seeing the extraordinary in ordinary things. No matter your travels, you'll view the sights with increased clarity and perspective. Thinking as a cartoonist can be a private pleasure and nothing more (though few things are greater than personal satisfaction).

For myself, cartooning is a tongue-in-cheek spirit, a wry philosophy that lends pleasure and understanding to my life's journey.

I can't ask for more.

Bibliography

Though cartoonists are widely scattered, cartoon books, newsletters, magazines and online features are more numerous.

The risk of mentioning any resource is that it might dry up and bounce away like a tumbleweed. On the Internet, simply typing **CARTOON** into a search engine should deliver you to active sites. As for print publications, here are a few that seem durable (any one of which will often carry ads for other publications).

Magazines and Newsletters

The Artist's Magazine
1507 Dana Avenue
Cincinnati, OH 45207
Offers the occasional feature on cartooning.

Cartoonist PROfiles
P.O. Box 325
Fairfield, CT 06430
A quarterly magazine featuring interviews and profiles of mostly syndicated cartoonists.

Cartoon Opportunities
P.O. Box 248
Chalfont, PA 18914
A source for markets and information.

Cartoon World
P.O. Box 1164
Kent, WA 98035-1164
A good place to find markets and read about other cartoonists.

Encouraging Rejection
P.O. Box 750
Intervale, NH 03845
This is the newsletter I publish, featuring interviews with beginning and experienced cartoonists. The focus is on the challenge of submitting work and dealing with rejection.

Gag Recap
12 Hedden Place
New Providence, NJ 07974
When you begin writing cartoons, this newsletter reveals what other cartoonists are writing. It recapitulates hundreds of cartoons published in dozens of publications.

Hogan's Alley
P.O. Box 47684
Atlanta, GA 30362
A magazine of cartoon appreciation from a scholarly, historical and often humorous perspective.

Inks
Ohio State University
27 West 17th Avenue Mall
Columbus, OH 43210-1393
Another scholarly consideration of cartoons.

Pro 'Tooner
P.O. Box 2270
Daly City, CA 94017
Another source for markets and cartoon information.

Witty World
P.O. Box 1458
North Wales, PA 19454
Cartooning as an international activity.

Books

Bookshelves forever bow with the weight of how-to books. Though each may consider familiar material, the writer's point of view usually reveals something new.

Cartooning by Polly Keener (Harper Perennial).

Cartooning, the Art and the Business by Mort Gerberg (William Morrow and Company).

The Cartoonist's Muse by Mischa Richter and Harald Bakken (Contemporary Books).

Getting Started Drawing & Selling Cartoons by Randy Glasbergen (North Light Books).

How to Be a Successful Cartoonist by Randy Glasbergen (North Light Books).

'Toons! How to Draw Wild & Lively Characters for All Kinds of Cartoons by Randy Glasbergen (North Light Books).

Understanding Comics by Scott McCloud (Tundra Books).

Index

More Great Books for Cartoonists!